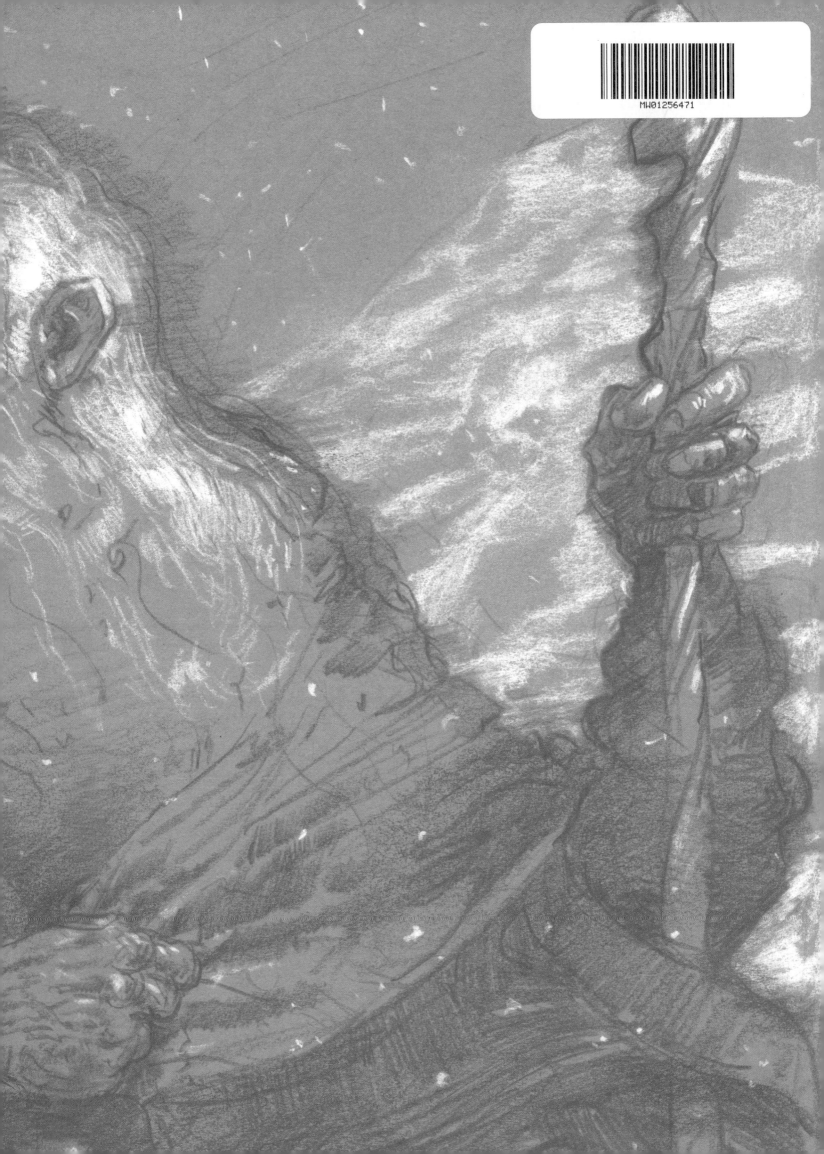

Middle-Earth

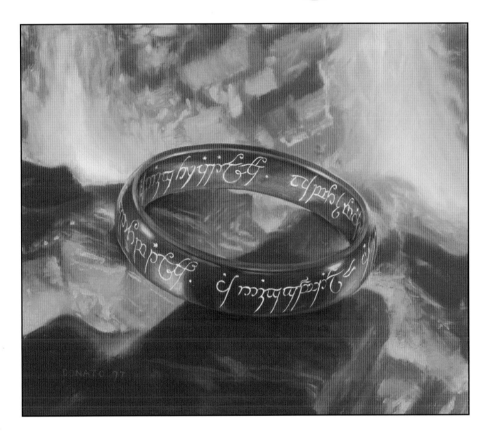

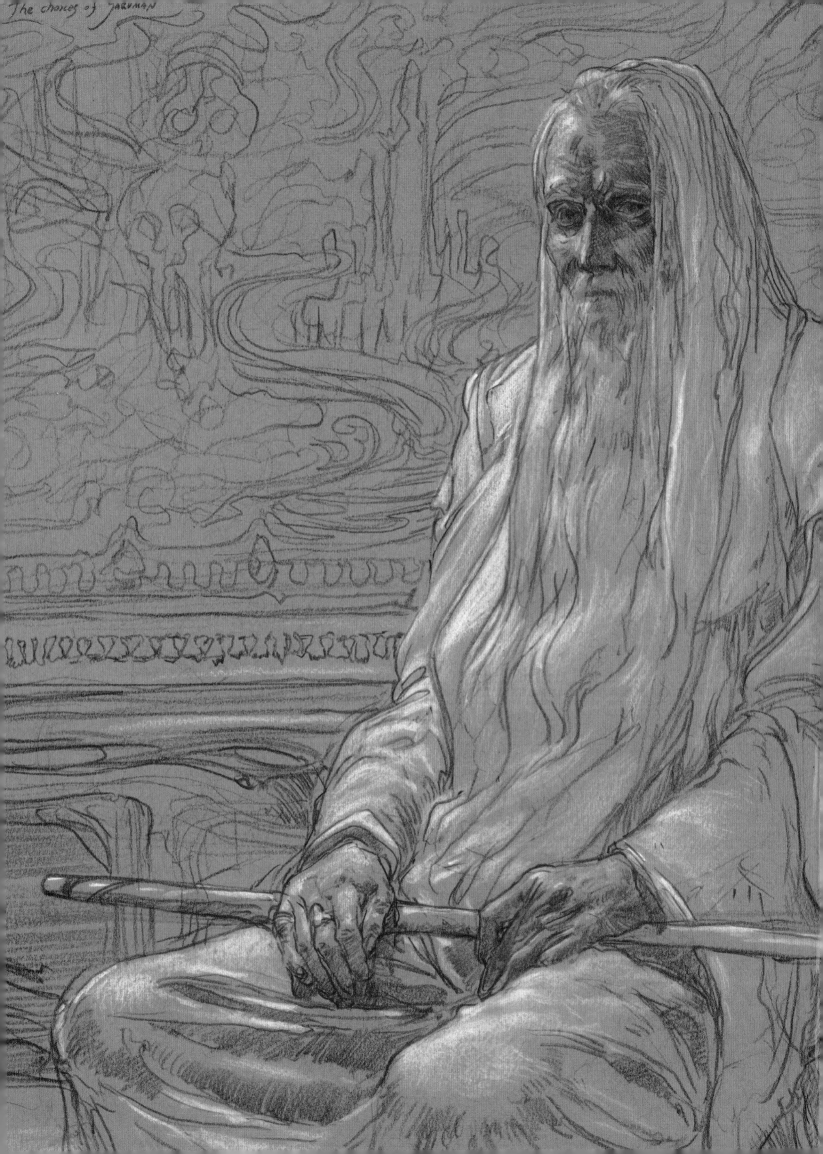
The choice of SARUMAN

Middle-Earth
Visions of a Modern Myth
Donato Giancola

Underwood Books • Nevada City, CA

DEDICATION & ACKNOWLEDGMENTS

For **Vinny** and all the years of imaginative adventures we took together.

And thanks go to my brother **Mike**, for handing me *The Hobbit*: "You might like to read this."

My strongest gratitude is extended to **Arnie** & **Cathy Fenner**, for all their years of support and encouragement, and for their specific help in publishing this book. To **Tim Underwood** whose belief in my visions finally bears fruit. And, not least, my special thanks go to **Kristina Carroll**, whose drafting and compiling helped make this book possible.

Finally, as always, I am humbly grateful for the support of my family: my eagle eyed wife, **Carey Johnson**; **my parents** who made sure I had paper and pencils on hand at all times; my brother **Dave** for supplying me with my first commissions; and the joy brought to me by my children, **Naomi** and **Cecilia**.

ISBN-10: 1599290472
ISBN-13: 978-1599290478

10 9 8 7 6 5 4 3 2 1

This book was also produced in a leather-bound edition limited to 26 copies, each containing an original drawing by Donato Giancola.

Half title page: "The Ruling Ring", 1997, 10" x 8", oil on panel. Collection of the artist.

Title page: "The Choice of Saruman", 2008, 13" x 10", watercolor pencil and chalk on toned paper. Private collection.

Copyright page: "No Living Man am I", 2009, 13" x 10", watercolor pencil and chalk on toned paper.

Page 8: "Bert the Troll", 2010, 14" x 17", watercolor pencil and chalk on toned paper.

Page 9: "Eagle's Rescue", 2008, 17" x 14", watercolor pencil and chalk on toned paper. Collection of George Beahm.

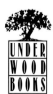

UNDER WOOD BOOKS

PUBLISHED BY
Underwood Books
P.O. Box 1919
Nevada City, CA 95959
www.underwoodbooks.com
Tim Underwood/Publisher

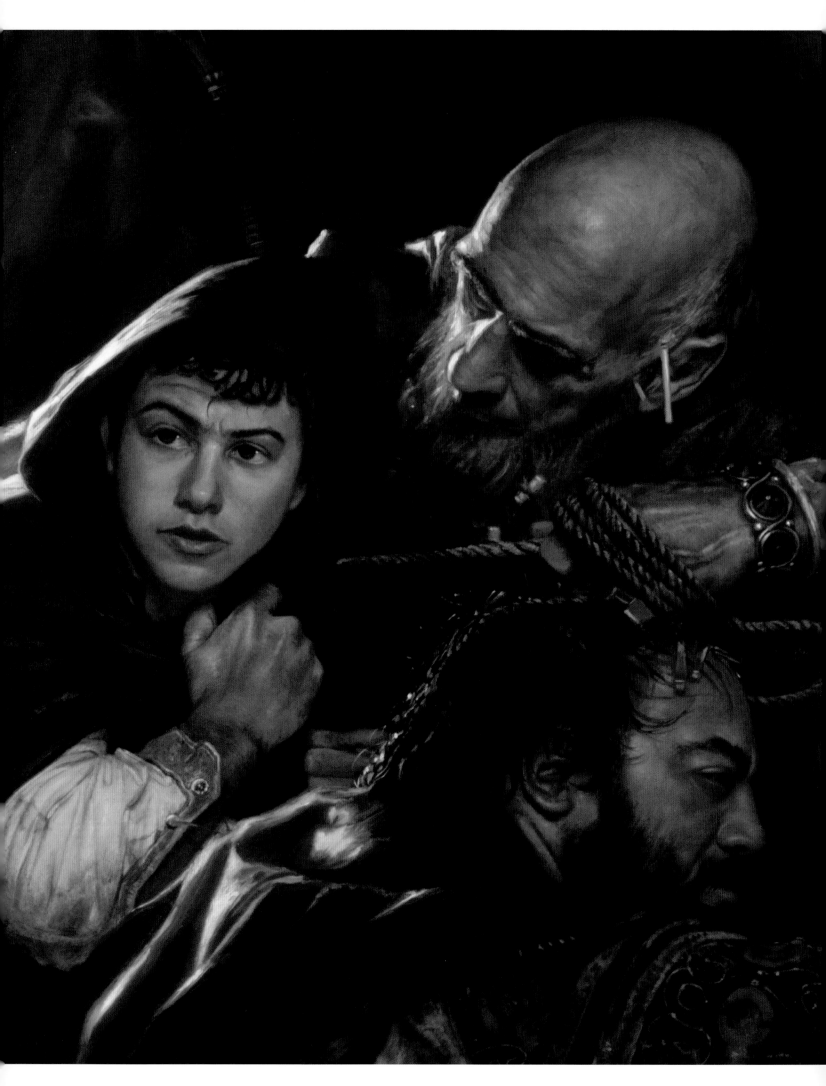

A Modern Master
Introduction by Ted Nasmith

If there is one word I could use to describe Donato Giancola's art, it would have to be *exuberant*. Donato is what is sometimes referred to as an "artist's artist," a master draftsman capable of creating a seemingly endless number of exquisitely researched, delicately rendered, but powerfully vivid visions of imaginary and real people, creatures, scenes, and places.

He is among the most accomplished illustrators in the industry, to me, and his varied images show a keen and seemingly inexhaustible curiosity and delight in compositional and image possibilities within the perimeters of his signature high realism style. I know the excitement that drives him.

There are many artists who excel in a particular realm, but who shy away from confronting technical challenges outside their zone of comfort, such that their work becomes relatively limited and predictable. With Donato, you have a man who makes it his business to be accomplished in many disciplines: superb human and animal anatomy, drapery and costume, otherworldly and terrestrial architecture in abundance, full command of perspective, landscape, macro and micro forms, dynamic composition, extraordinarily mature colour skill, inventiveness, and all with superb attention to detail and tonal dynamics. His art is exactingly and lovingly rendered with consummate skill, yet the end result is typically relaxed and very pleasant to the eye—no easy feat. While displaying these various disciplines within the picture frame, he skillfully integrates them into a harmonious whole, a key area of accomplishment for any of us, especially as we manipulate images to our client's requirements. As a fellow fantasy artist, I particularly enjoy his forays into the fantastic (and recognize in him a formidable competitor!), but he is just as likely to immerse himself in history, conventional fiction, poetry, science fiction, and many other realms.

Doubtless the most striking aspect of Donato's artwork is the impression that he stepped out of an 18th century French or Italian atelier, of course. His is a rare gift for bringing a look and a multi-disciplinary mastery which has nearly disappeared in our era into full, glorious new life and applying it to a wide range of illustrative projects. Ever since he began creating his legacy, he has been raising the art of illustration to heights it rarely achieves in our hasty, disposable modern world. Long may he delight us.

—*Ted Nasmith*
2010

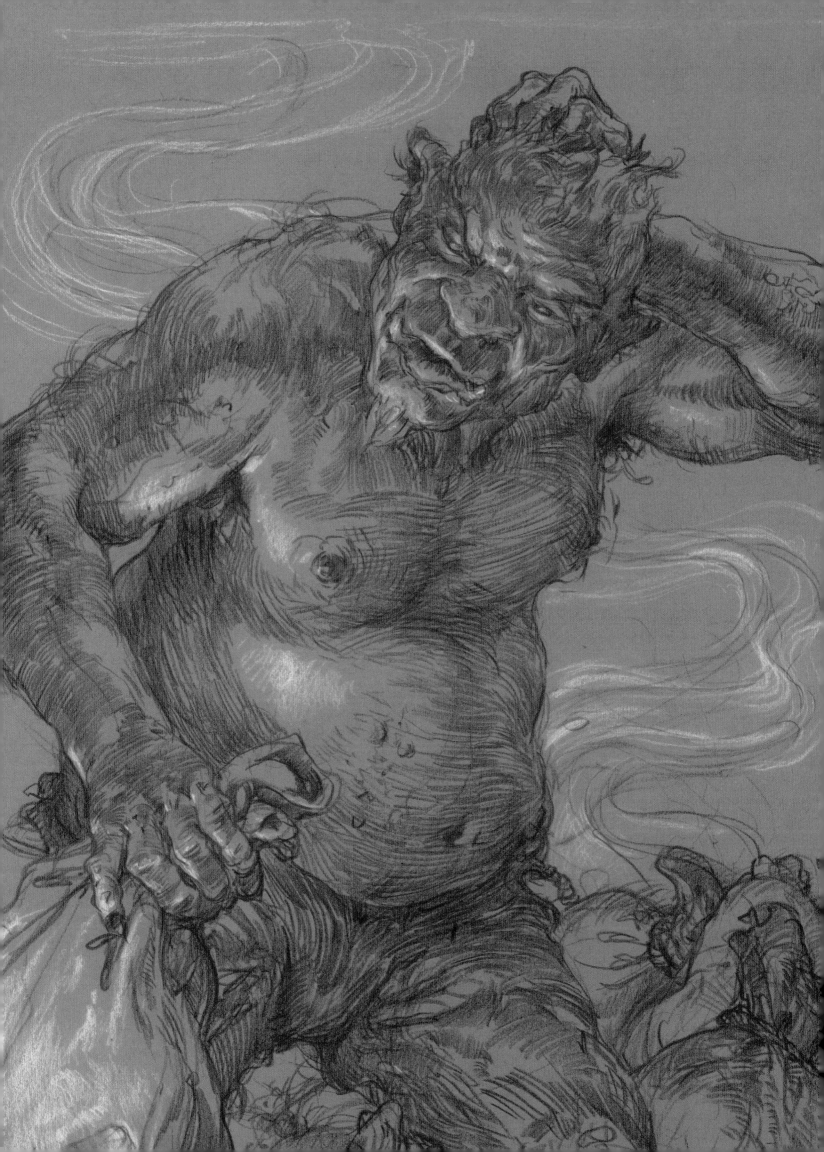

Middle-Earth

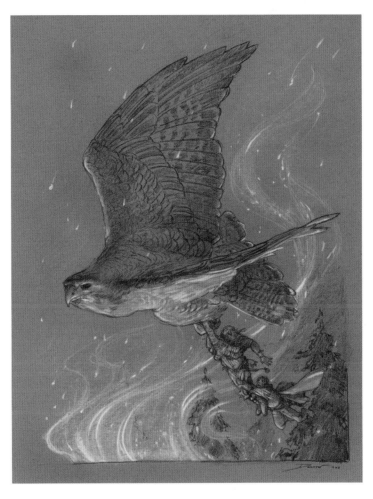

Visions of a Modern Myth

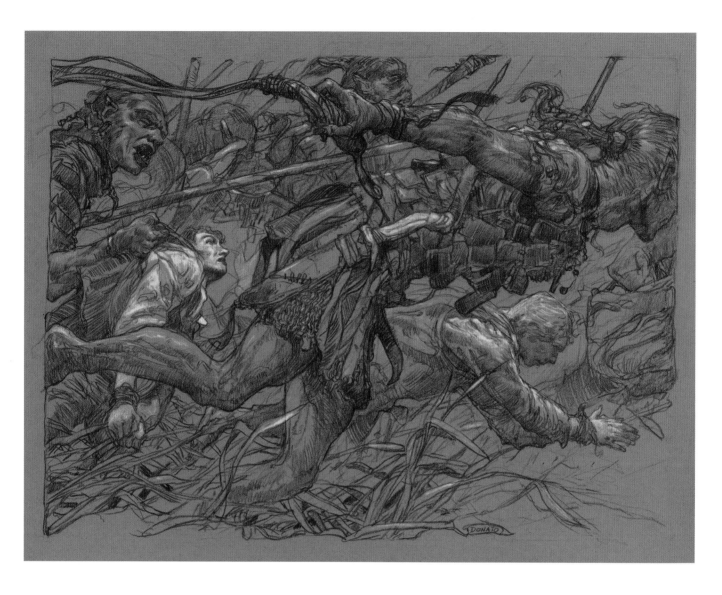

You Cannot Pass!

Gandalf's dual identity as councilor and hero makes his loss on the bridge of Khazad-dûm especially tragic for the Fellowship, but his sacrifice fosters the other characters' growing confidence and inner strength. In Gandalf's absence, Aragorn embraces his role as a leader, Boromir finds an opening to attempt to take the ring, and Frodo finds the courage to abandon the Fellowship and make his own way.

Faramir at Osgiliath [*overleaf*]

After his brother Boromir's death, Faramir struggles to please Denethor, his increasingly insane father, demonstrating admirable but nearly fatal loyalty. Boromir had acted as a buffer between father and younger son, and, in his absence, their relationship deteriorated.

Above: "A Sudden Thought"
2010, 17"x14", watercolor pencil and chalk on toned paper.

Opposite: "You Cannot Pass!"
2007, 24" x 30", oil on panel. Private collection.

Overleaf: "Faramir at Osgiliath"
2003, 55" x 37", oil on panel. Private collection.

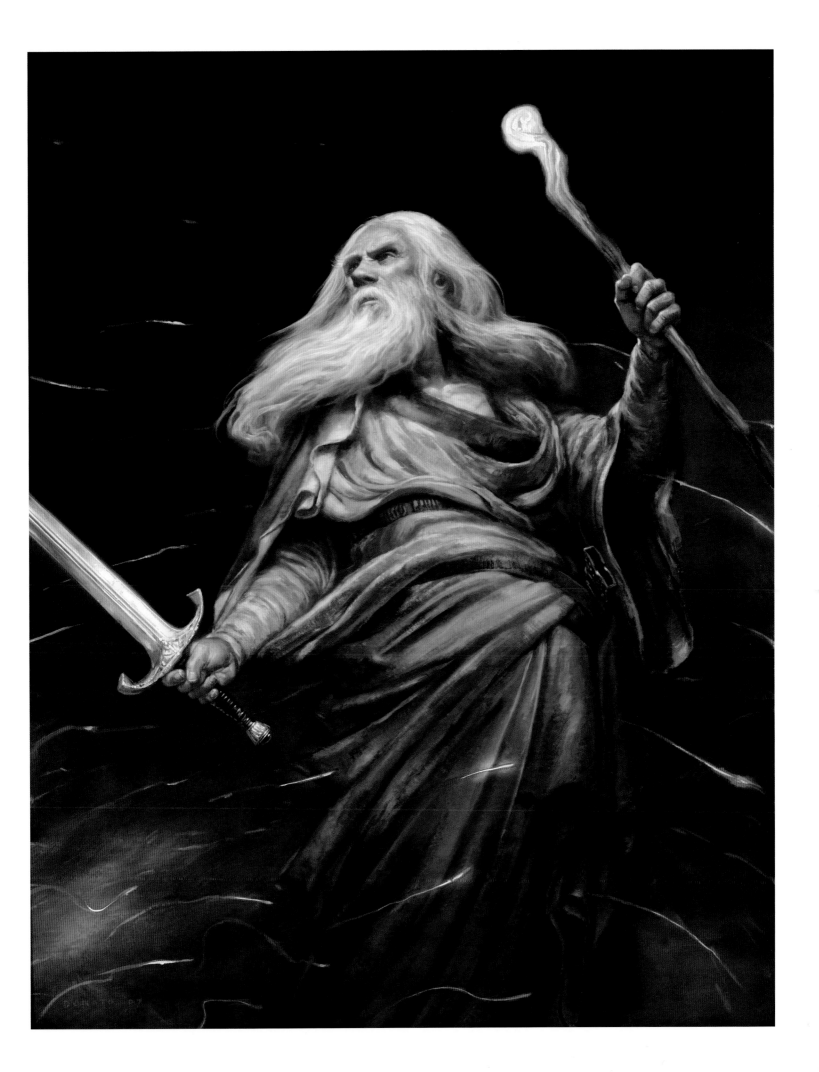

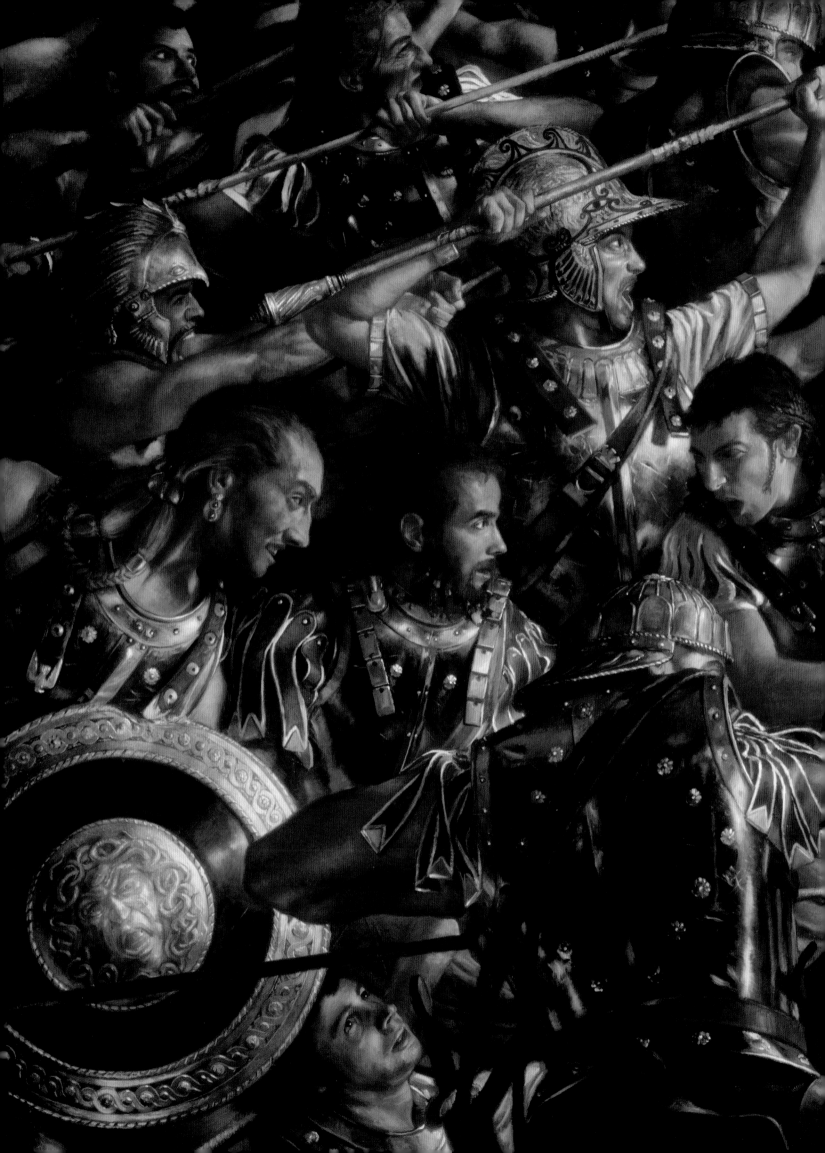

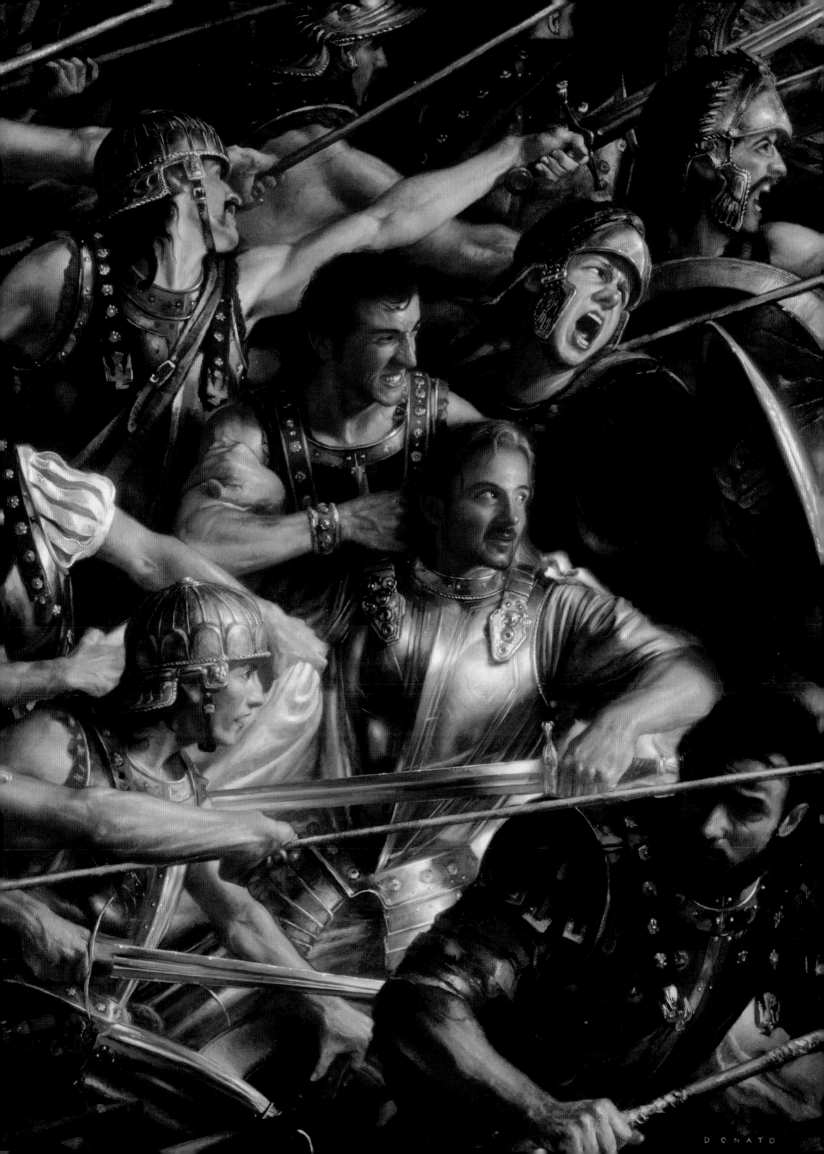

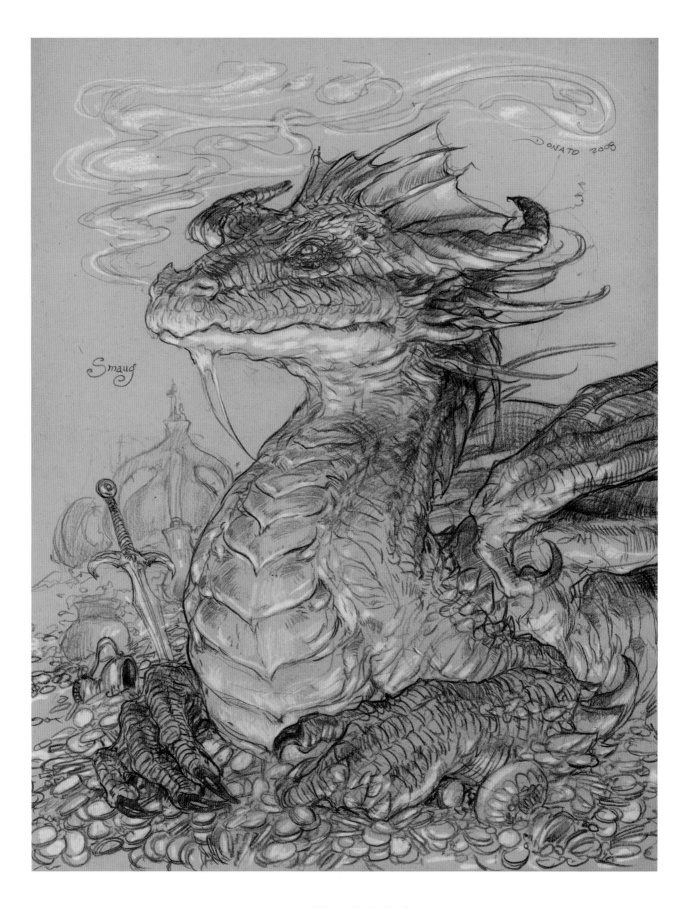

Smaug

Above: "Smaug the Golden"
2008, 11" x 14", watercolor pencil and chalk on toned paper. Collection of Britton and Jacob Edwards.

Opposite: "Lunch with William, Bert and Tom"
2010, 24" x 36", oil on panel.

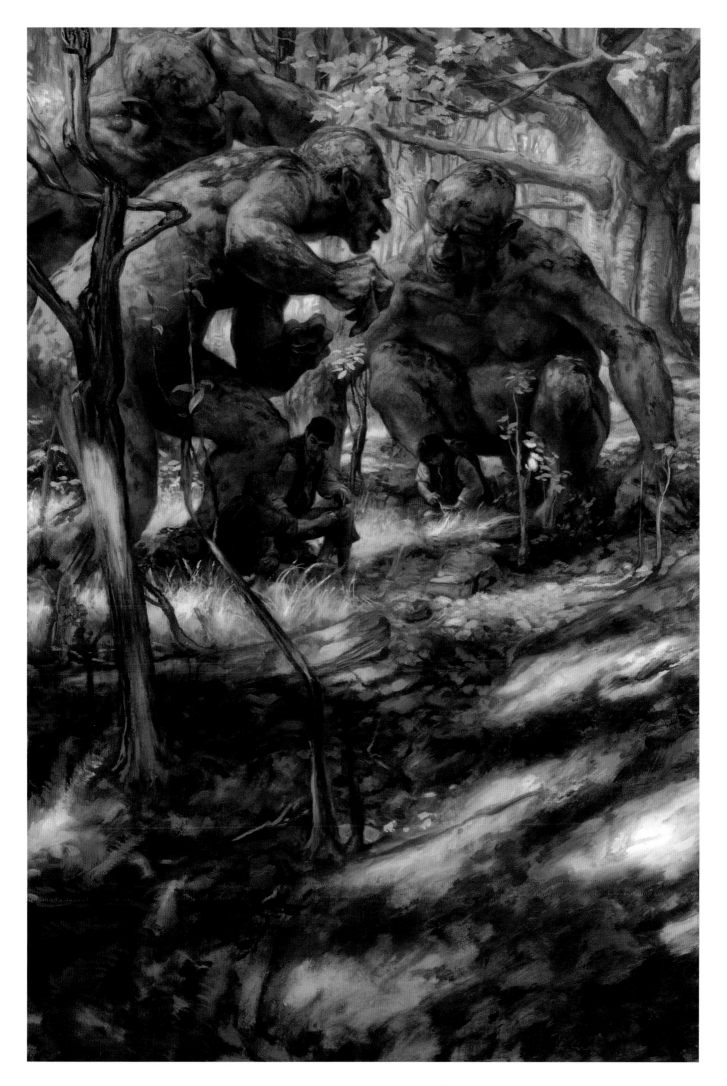

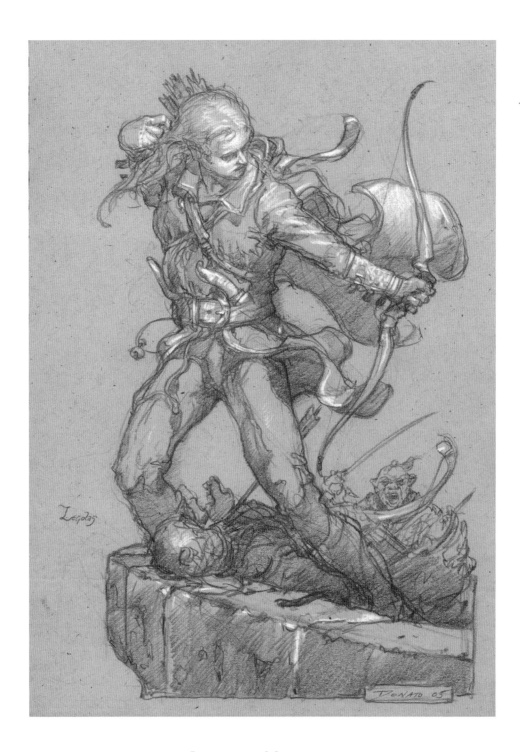

LEGOLAS OF MIRKWOOD

Tolkien's lack of specificity in his descriptions of characters is a gift to artists and possibly one reason his books continue to be such a rich source of imaginative inspiration. A Mirkwood elf, Legolas blends harmoniously with his natural environment. The painting's setting serves not only as an allegory for the passing of elves from Middle-earth but also as a nostalgic nod to my childhood in the forests of Vermont.

ABOVE: "Legolas at Helm's Deep"
2005, 9" x 12", watercolor pencil and chalk on toned paper. Private collection.

OPPOSITE: "Legolas in Mirkwood"
2009, 24" x 30", oil on panel. Private collection.

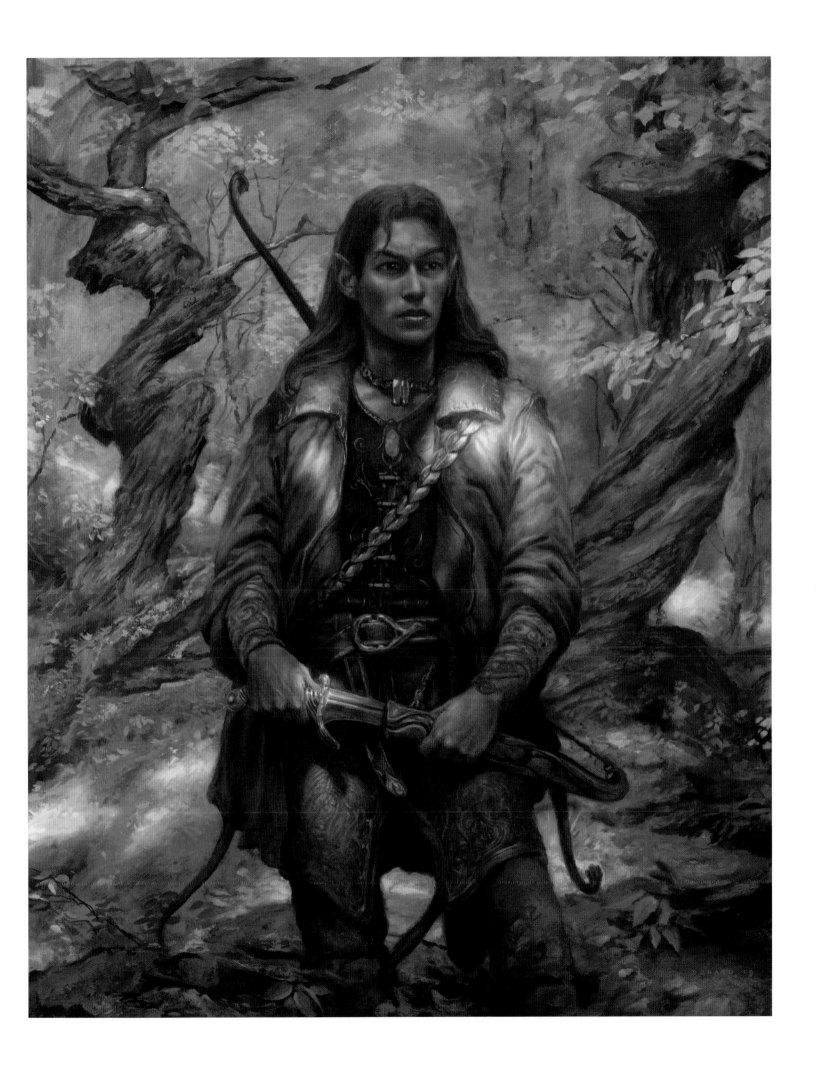

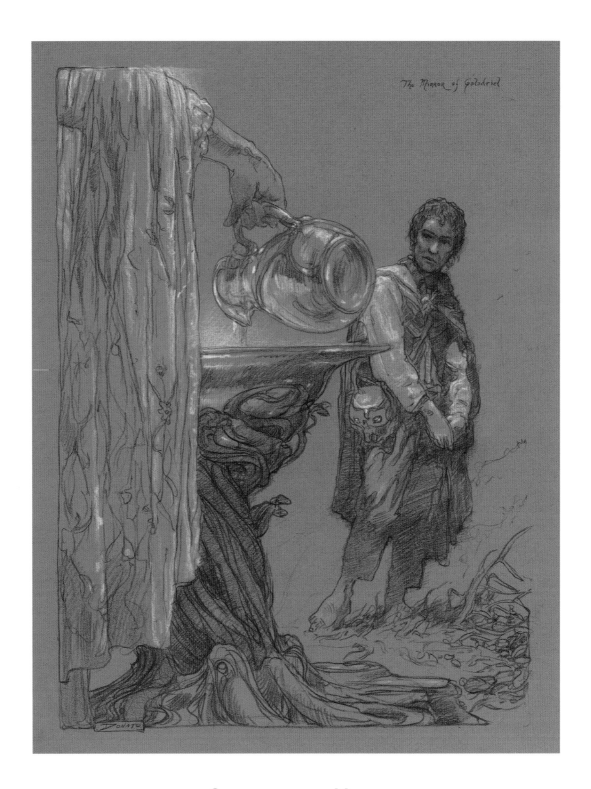

Galadriel and the Mirror

Undergoing Galadriel's omniscient scrutiny could never be comfortable. Her beautiful gaze is both compelling and unsettling to endure.

Above: "Do You Wish to Look?"
2010, 14" x 17", watercolor pencil and chalk on toned paper.

Opposite: "Galadriel and the Mirror"
2002, 27" x 38", oil on panel. Private collection.

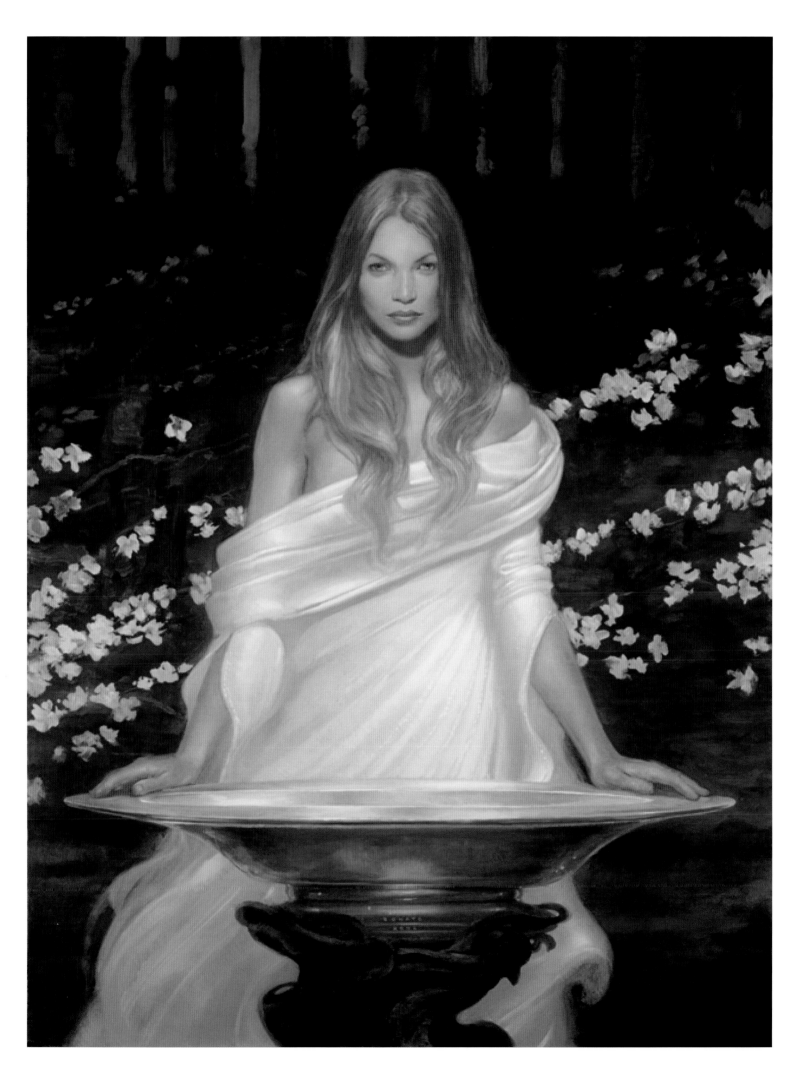

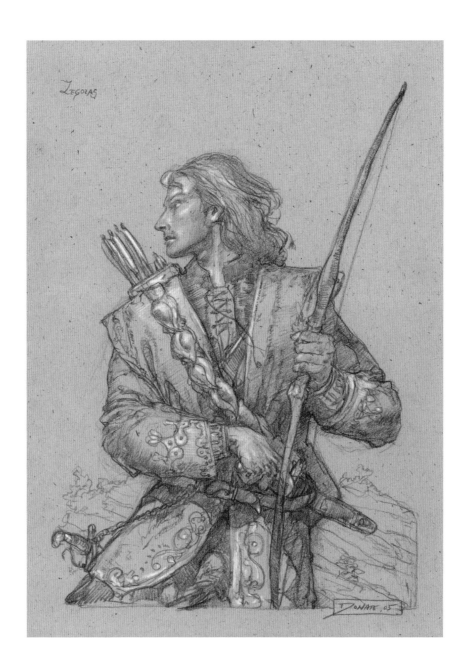

Boromir in the White Mountains

It is easy to characterize Boromir as simple and headstrong, but here he is depicted as a proud man conflicted by his duties as son, royal protector and royal emissary. Possessing great courage, he lacked the inherent wisdom of Westernesse which ran truer in his brother Faramir. Although never a villain, Boromir was one of Tolkien's most human characters, constantly at battle between duty and morality, a figure of Shakespearean tragedy.

Falls of Rauros [*overleaf*]

Though passed through briefly in the narrative, the Falls of Rauros link living men to their history and their destiny. Lying just beyond the Argonath and leading to Minas Tirith, Rauros and its river Anduin carry Boromir's body homeward after his death and onward to the sea, home of lost Numenor, the ancient kingdom of men.

Above: "Legolas at Amon Hen"
2005, 10" x 14", watercolor pencil and chalk on toned paper. Private collection.

Opposite: "Boromir in the White Mountains"
2005, 18" x 25", oil on panel, collection of Pat and Jeanne Wilshire.

Overleaf: "The Falls of Rauros"
In progress, 48" x 80", oil on panel.

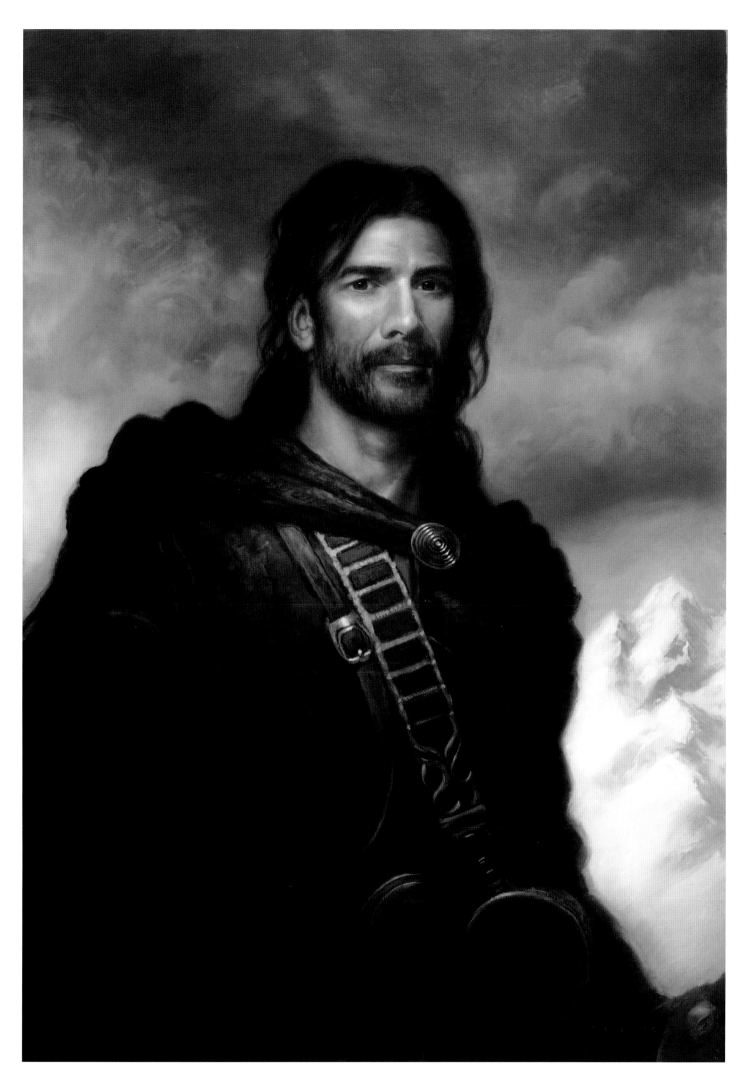

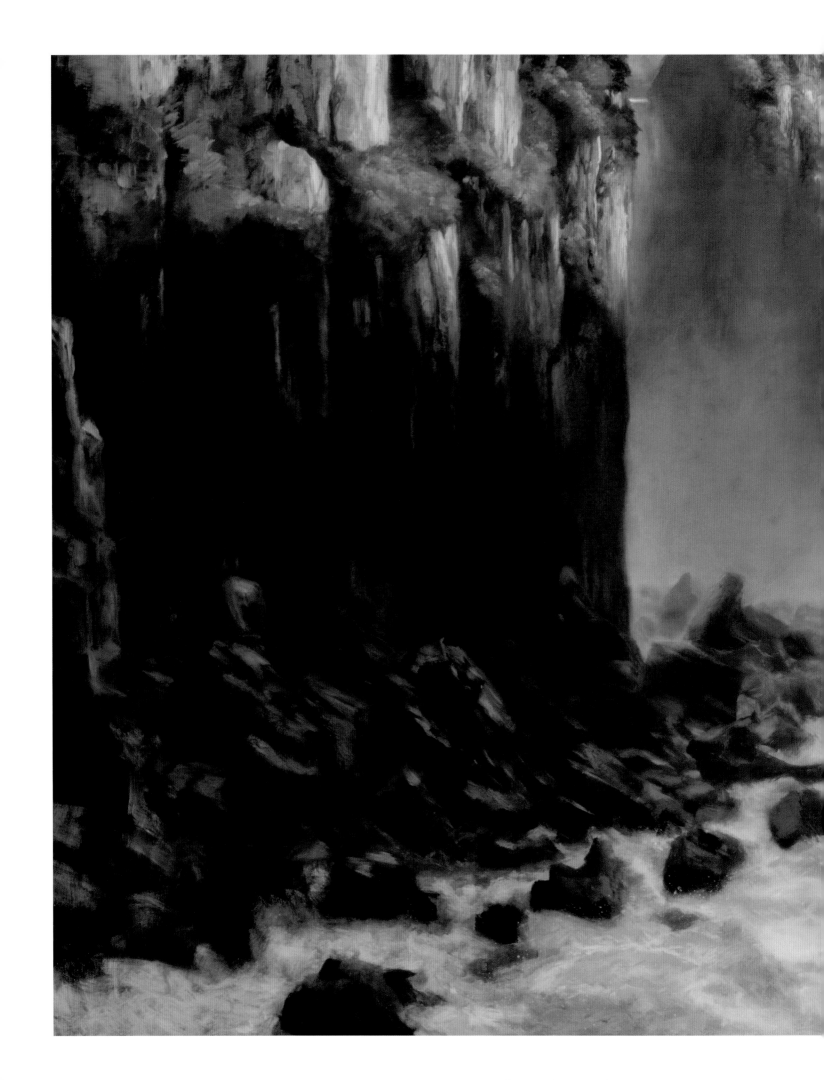

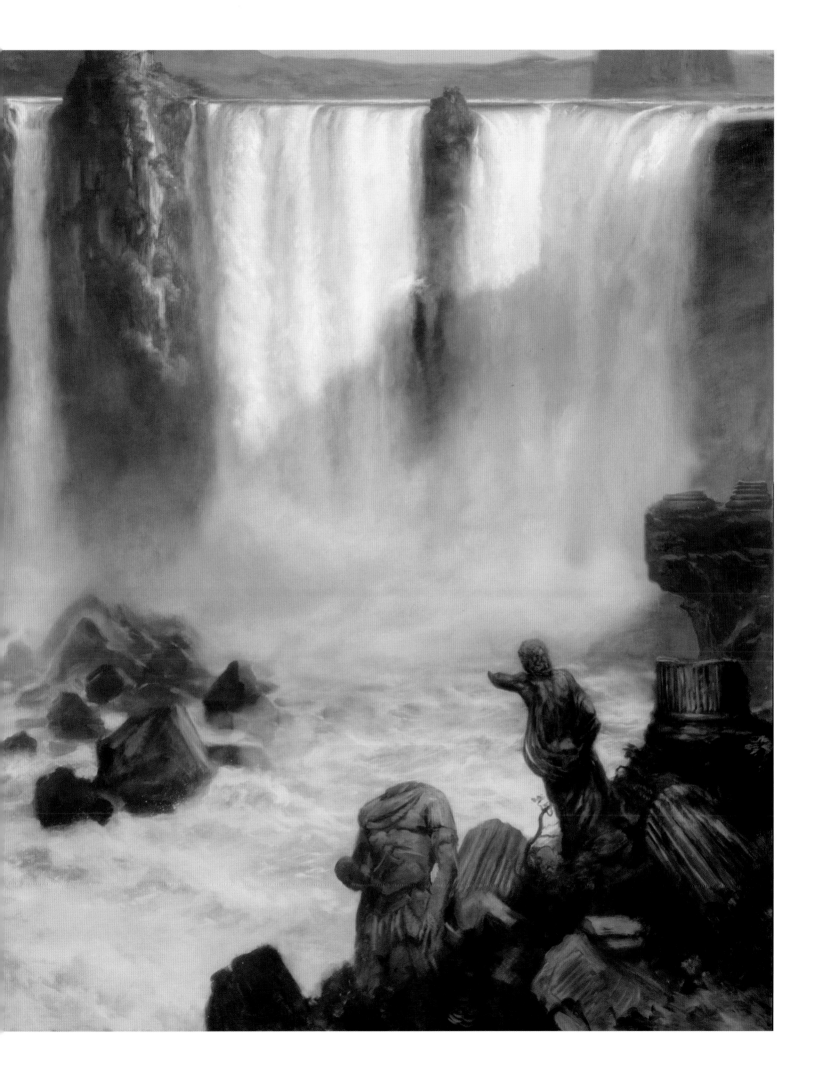

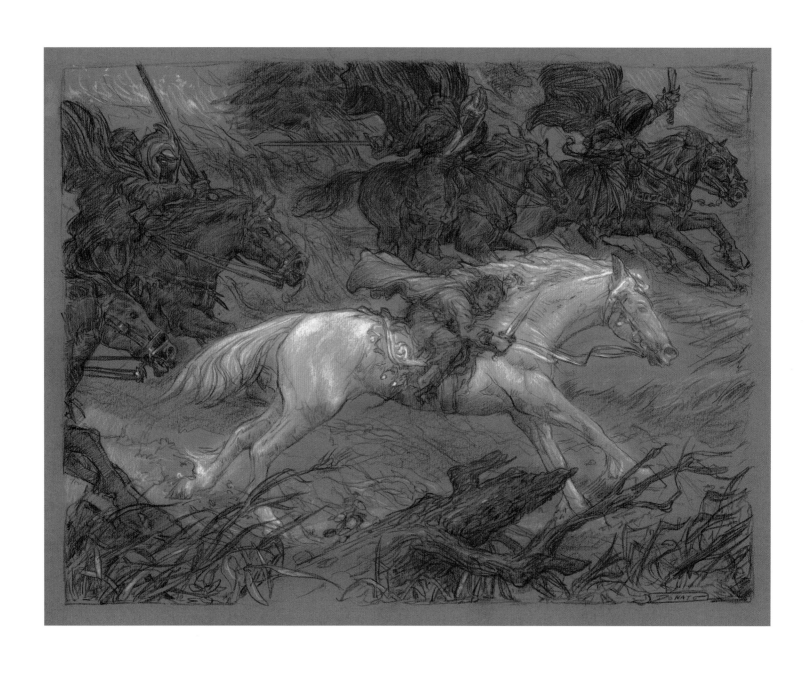

ABOVE: "Flight to the Ford"
2010, 17" x 14", watercolor pencil and chalk on toned paper.

OPPOSITE: "Gandalf — Revelation of the Ring"
2008, 10" x 13", watercolor pencil and chalk on toned paper. Private collection.

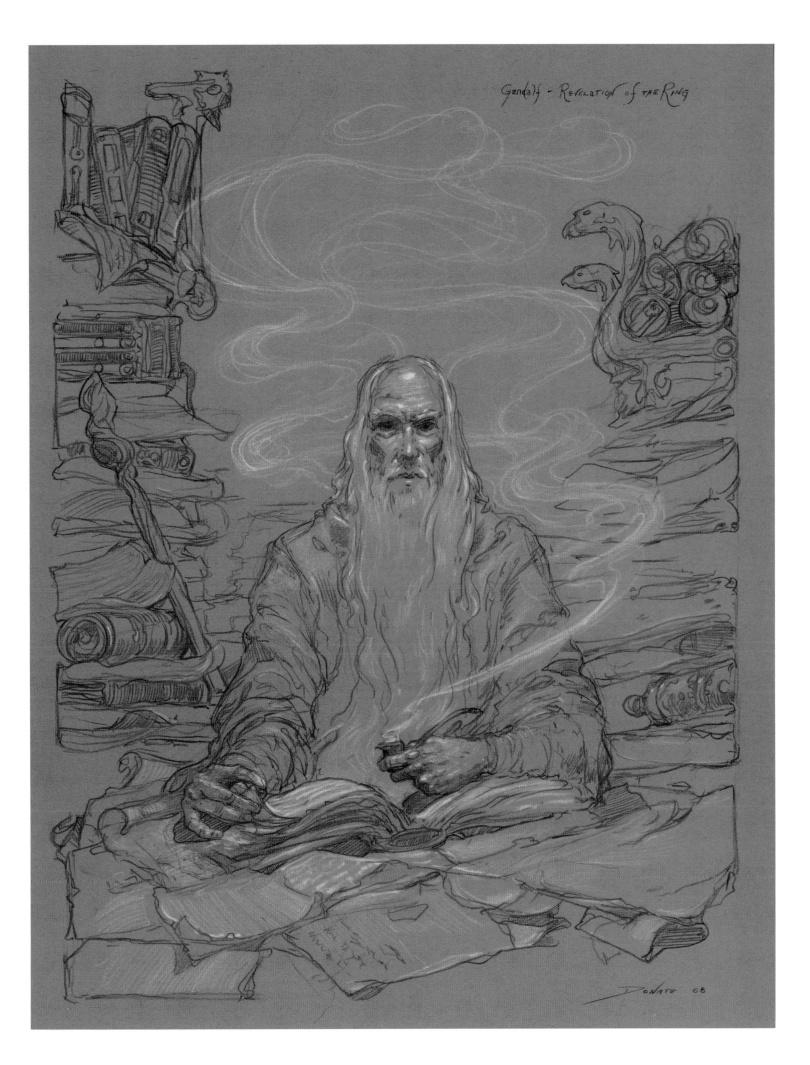

Gandalf — Revelation of the Ring

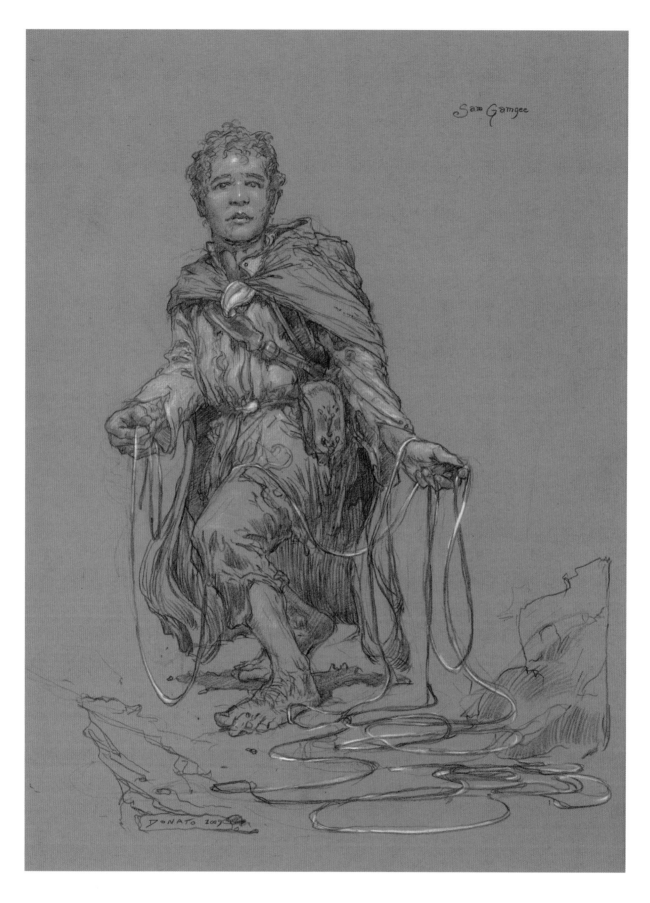

ABOVE: "Sam Gamgee"
2009, 13" x 17", watercolor pencil and chalk on toned paper.

OPPOSITE: "Frodo in Ithilien"
2004, 9" x 11", watercolor pencil and chalk on toned paper. Private collection.

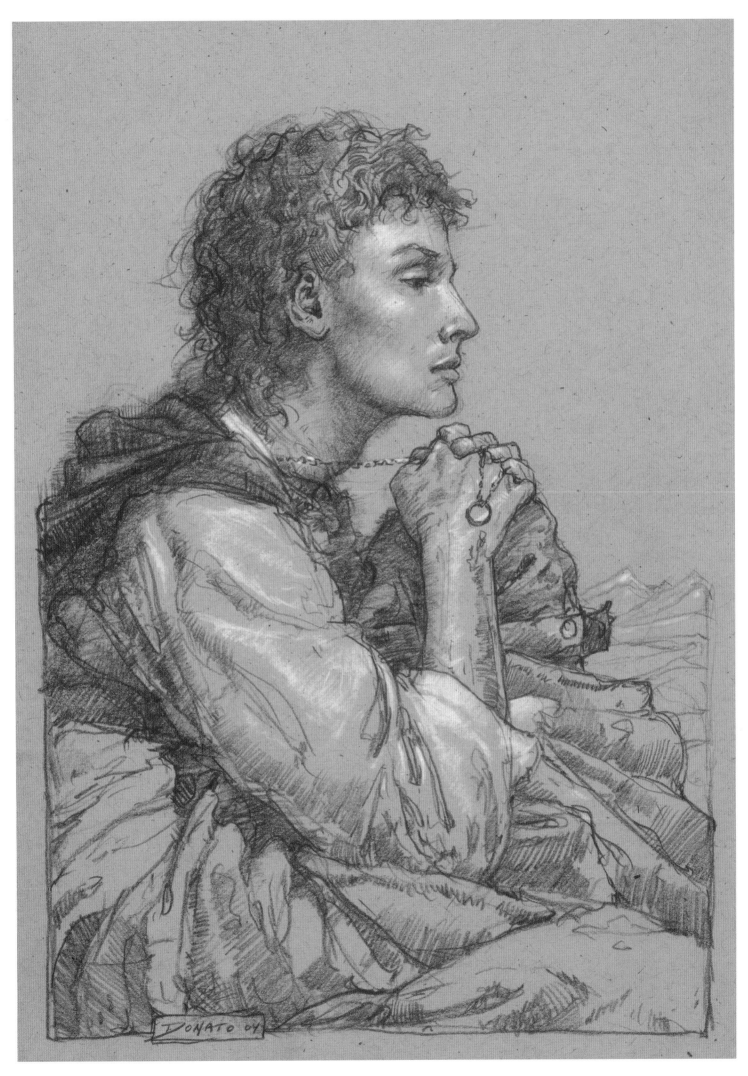

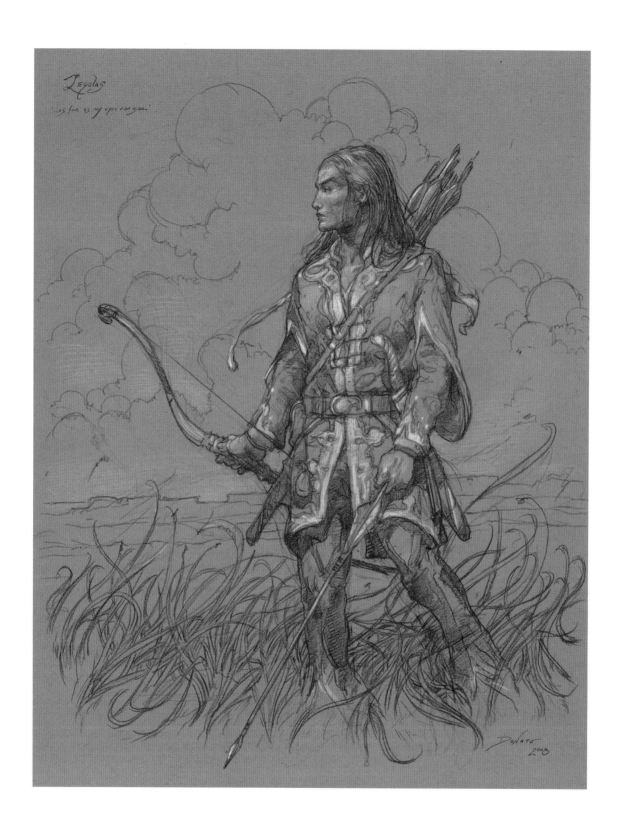

ABOVE: "Legolas: As Far as the Eyes Can See"
2008, 10" x 13", watercolor pencil and chalk on toned paper. Private collection.

OPPOSITE: "Search in Rohan"
2010, 24" x 30", oil on panel.

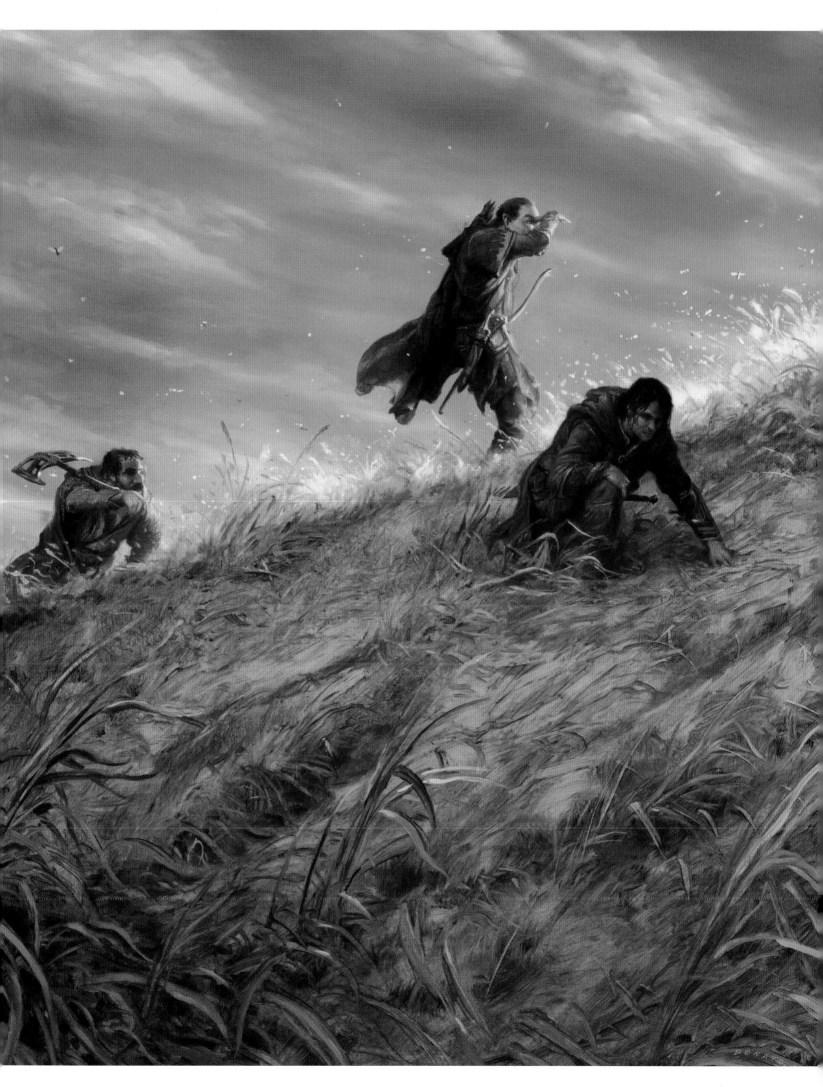

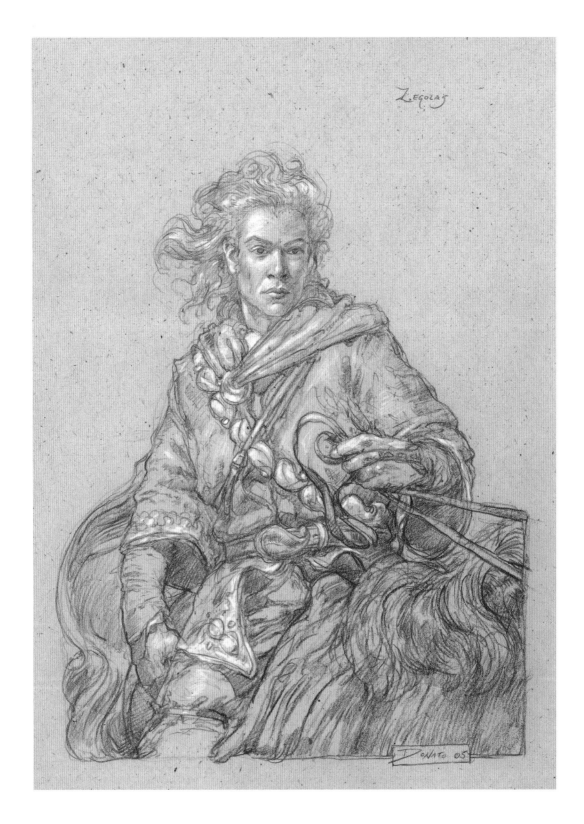

LEGOLAS AND GIMLI

The relationship of Legolas and Gimli is one of the most fascinating in *The Lord of the Rings*. The nature of their shared trials as part of the Fellowship opens their eyes to each other's kind humanity – a wonderful demonstration that true character qualities arise when individuals are under great duress. The importance of Gimli's friendship with the elves, and Tolkien's affection for the dwarf, is emphasized in the books' appendices: Gimli was allowed to travel to Valinor, the only dwarf ever to do so.

ABOVE: "Legolas in Rohan"
2005, 10" x 14", watercolor pencil and chalk on toned paper. Private collection.

OPPOSITE: "Gimli, Son of Gloin"
2009, 13" x 17", watercolor pencil and chalk on toned paper.

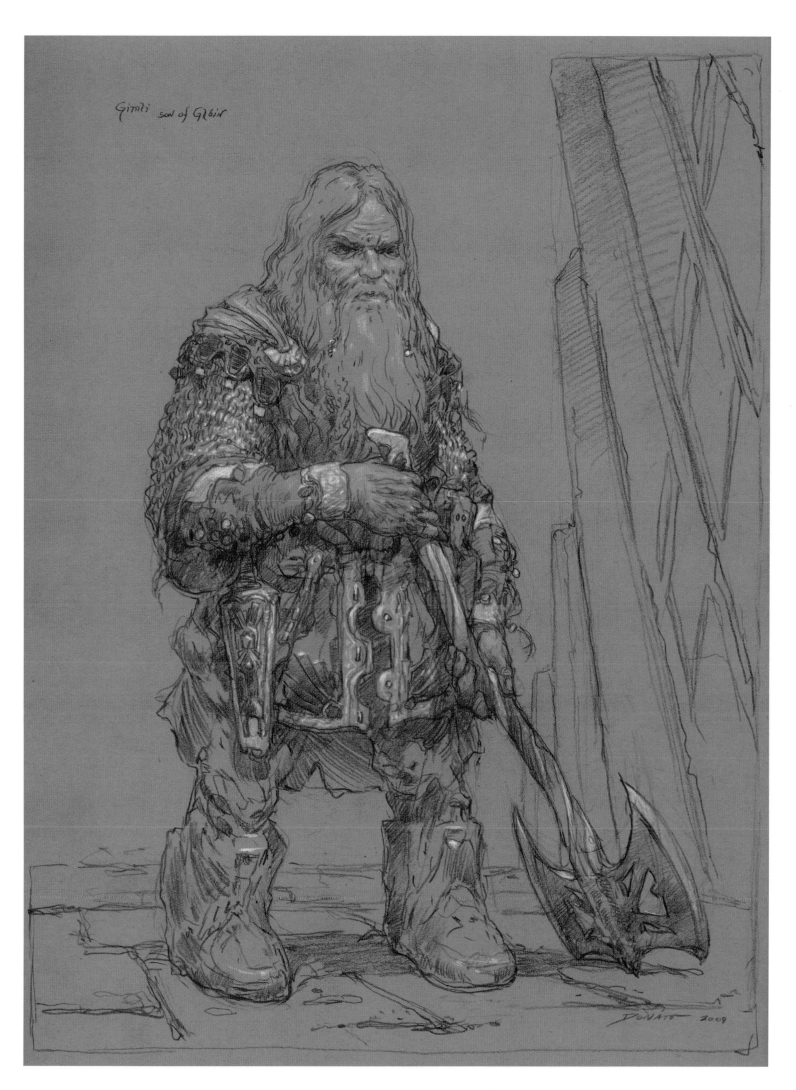

Gimli son of Glóin

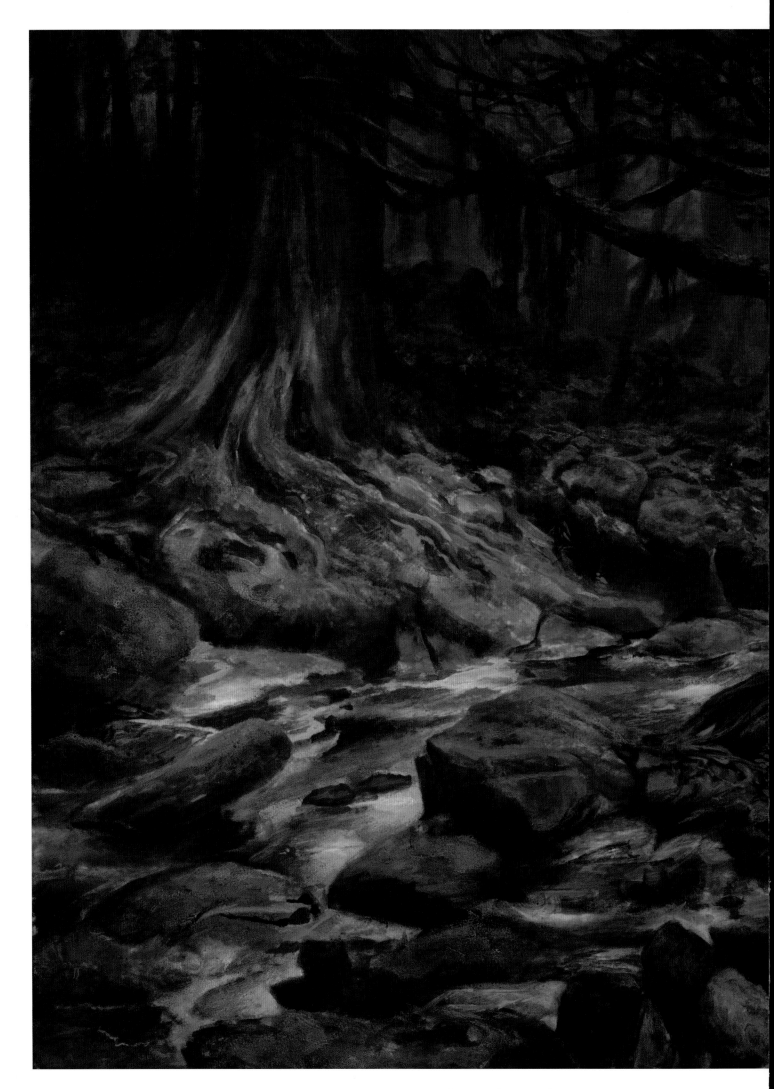

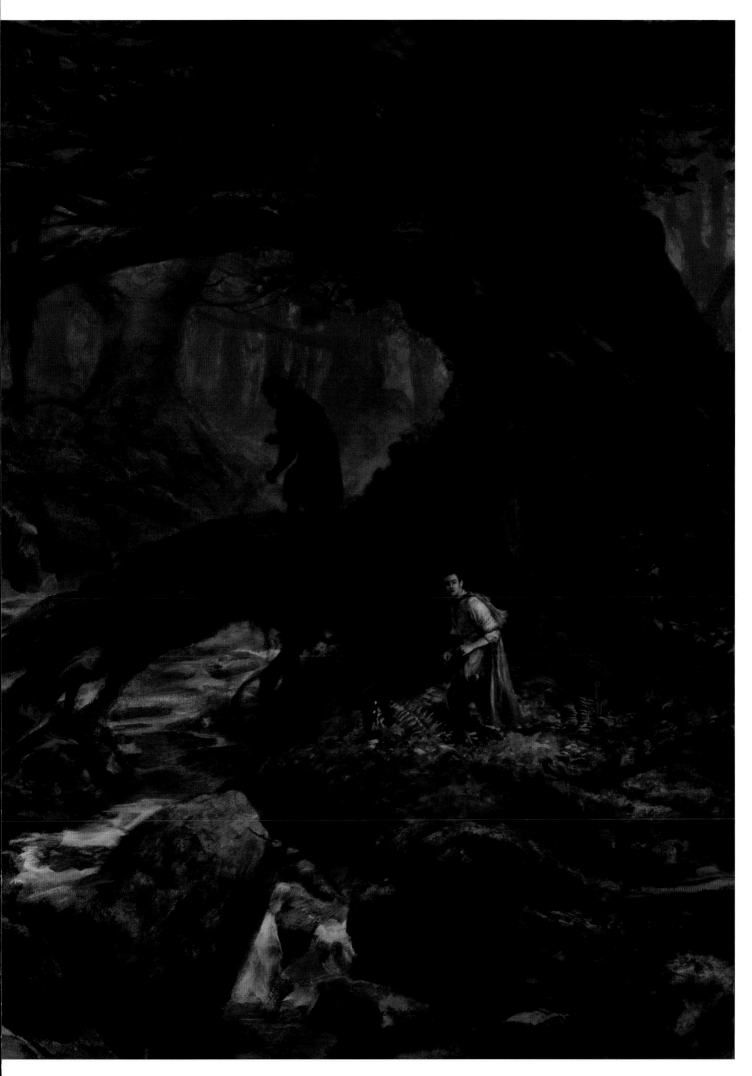

FARAMIR: ARTIFACTS FROM OSGILIATH

A companion painting to "Boromir in the Court of the Fountain," this image depicts Faramir's humble dedication to the task of preserving rather than commanding Minas Tirith. A background frieze alludes to both Faramir's respect for history and his skill as a warrior, traits displayed while protecting a treasure taken from Osgiliath, the former capital of Gondor. He crouches in wary defense against an unseen enemy, perhaps Sauron of Mordor or his father's wounding criticism.

PREVIOUS SPREAD: "Fangorn Forest"
2010, 24" x 36", oil on panel.

ABOVE: "Faramir"
2007, 9" x 12", watercolor pencil and chalk on toned paper. Private collection.

OPPOSITE: "Faramir: Artifacts from Osgiliath"
2006, 20" x 30", oil on panel. Collection of Kirk and Leah Dilbeck.

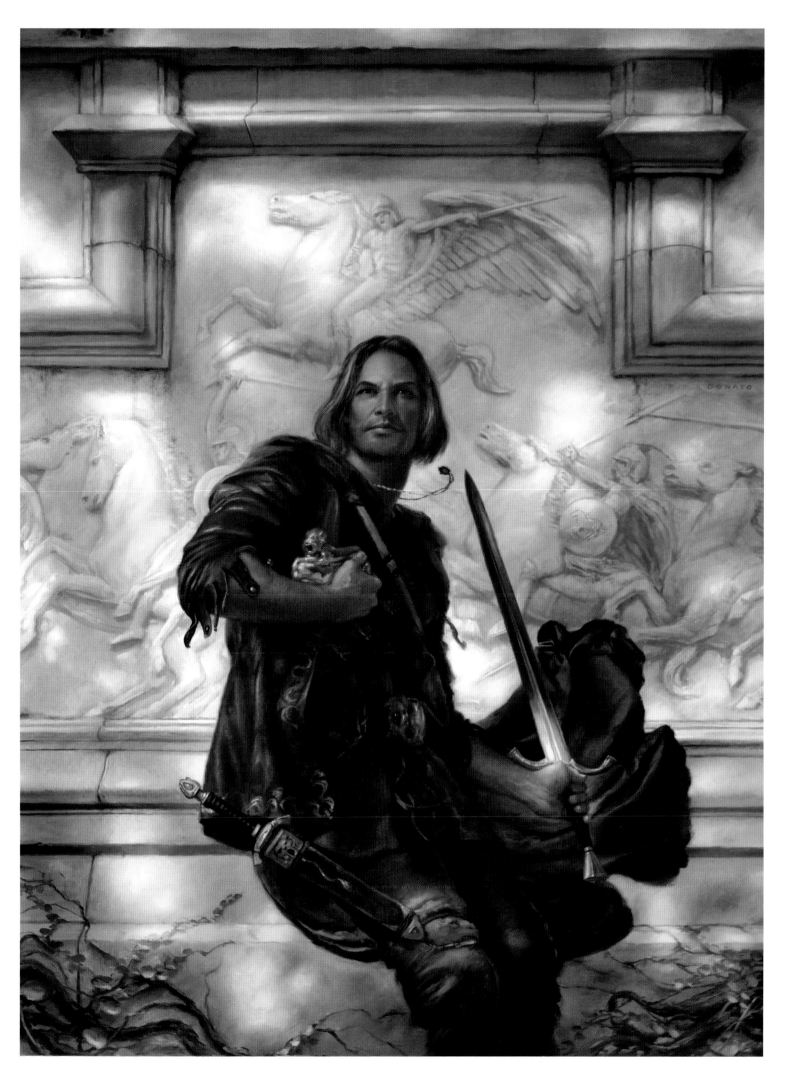

ᴄᴀ̃ᴢᴘᴀ̃ᴘ̃ʙᴘᴡᴘᴘᴘᴘᴘ̃ʏᴄ̃. Donato Giancola **35** ᴄᴘᴘʜʟᴢᴄᴘᴄᴘᴘᴘ̃ʏᴄ~

GANDALF AT CARADHRAS

Gandalf, the wise and powerful leader of the Fellowship, often experiences misgivings and self-doubt. I find myself returning to him again and again, creating more paintings and drawings of him than of any other character from the books. Gandalf is a lesser god, one of the Maiar, sent to Middle-earth specifically to aid the fight against Sauron. He entered the fray reluctantly, unsure of his own abilities. In this painting, as snow begins to fall, he debates testing the pass of Caradhras, a pivotal moment in the story.

TOP LEFT: "Denethor"
2007, 10" x 14", watercolor pencil and chalk on toned paper. Private collection.

TOP RIGHT: "Gandalf"
2010, 17" x 22", oil on panel.

ABOVE: "Gandalf at Minas Tirith"
2003, 13" x 10", watercolor pencil and chalk on toned paper. Private collection.

OPPOSITE: "Gandalf at Caradhras"
2002, 16" x 20", oil on panel. Private collection.

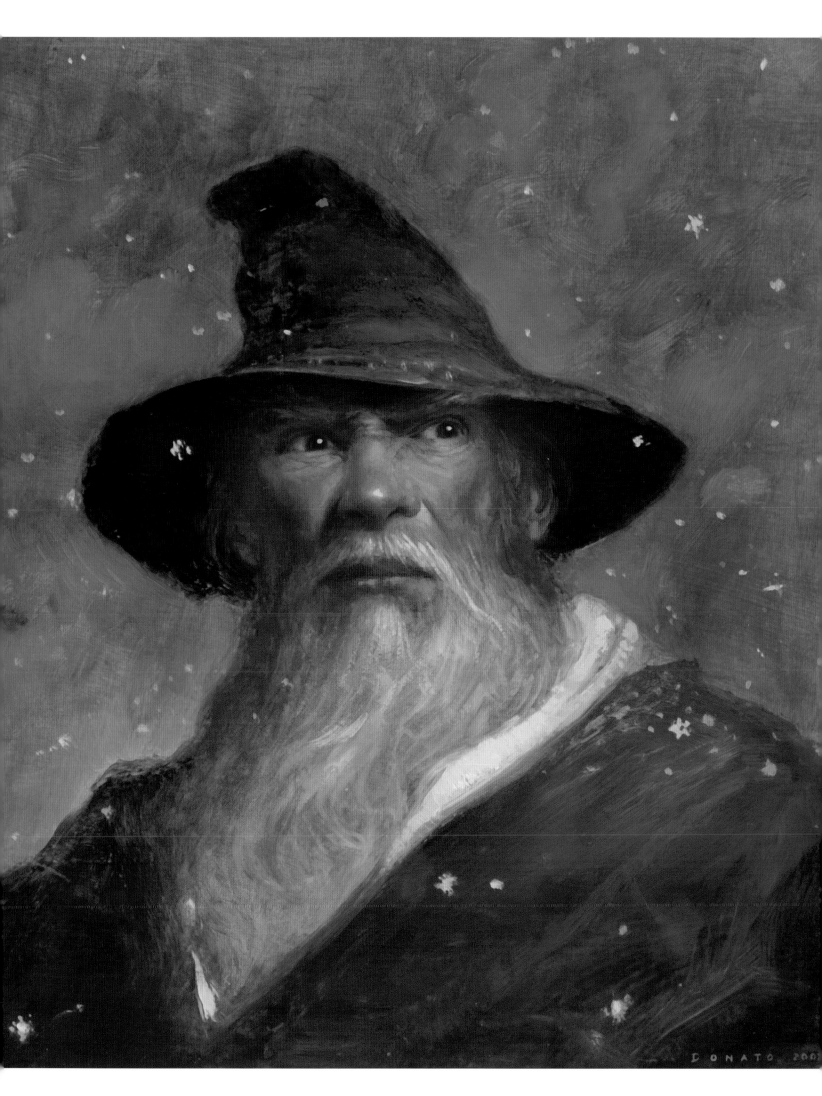

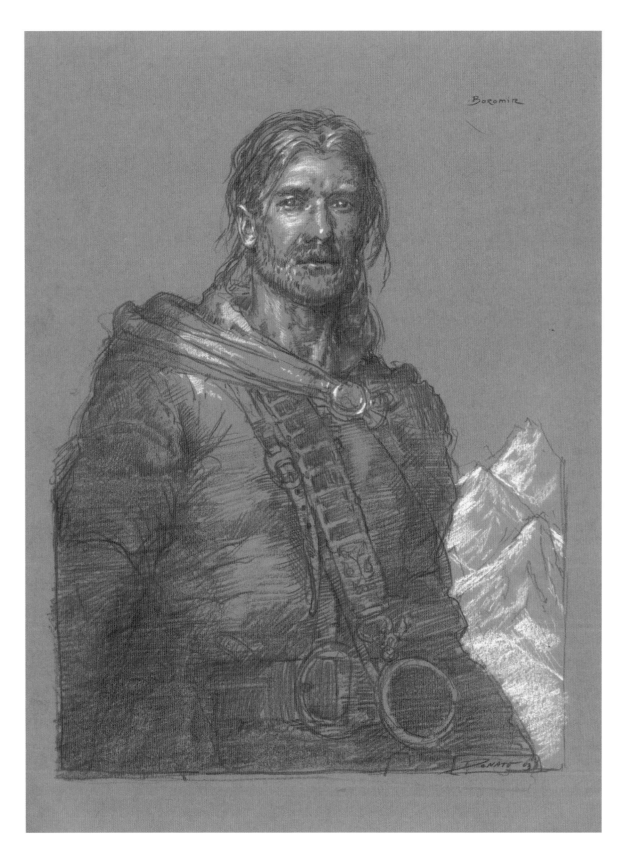

Above: "Boromir in the White Mountains"
2003, 10" x 13", watercolor pencil on toned paper. Private collection.

Opposite: "Faramir in Ithilien"
2006, 10" x 14", watercolor pencil and chalk on toned paper. Private collection.

Overleaf: "Boromir in the Court of the Fountain, Minas Tirith"
2005, 27" x 40", oil on panel. Private collection.

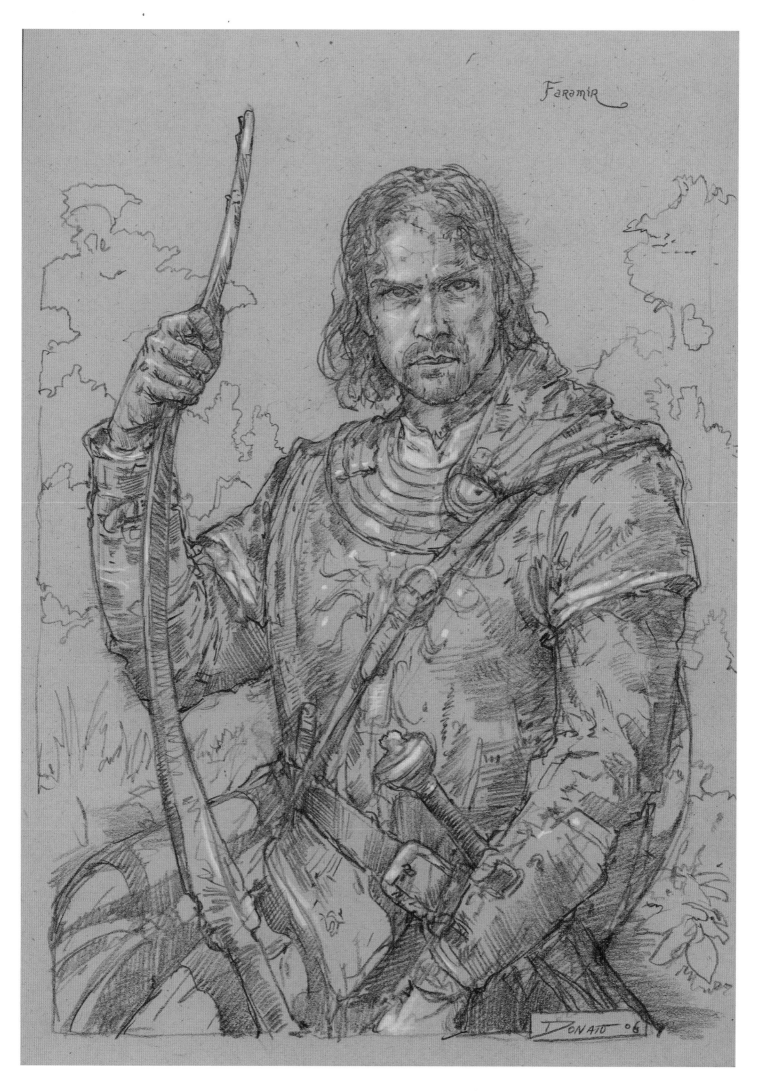

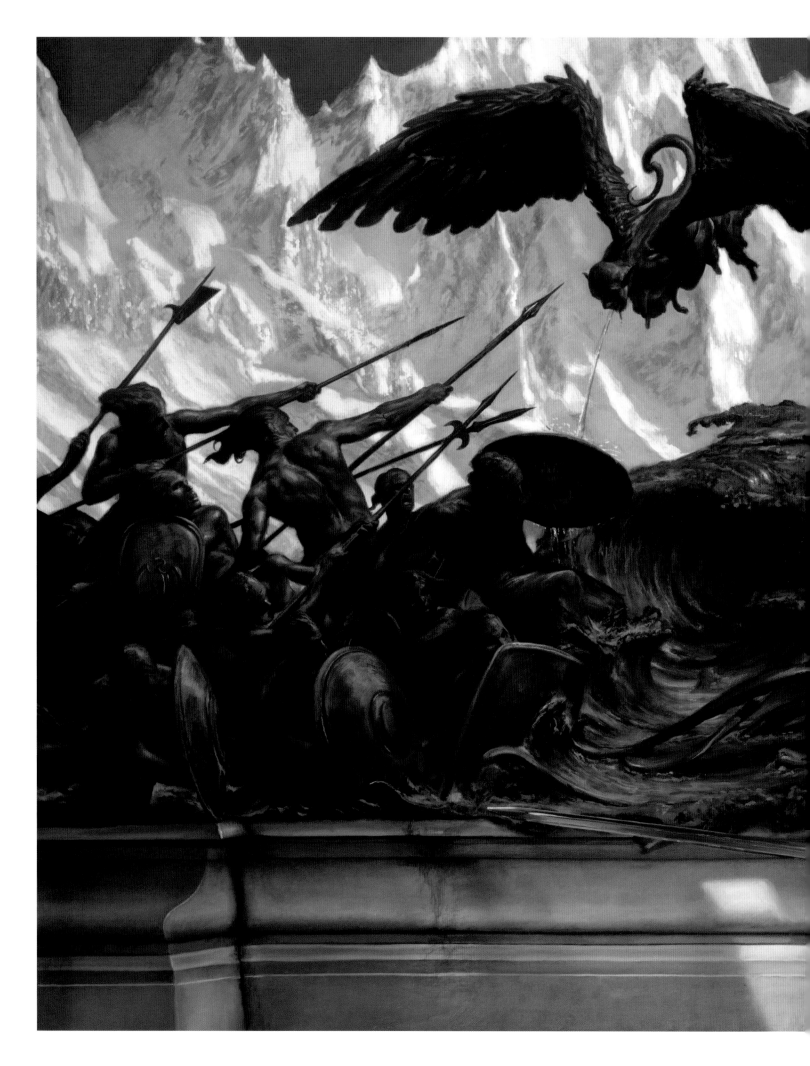

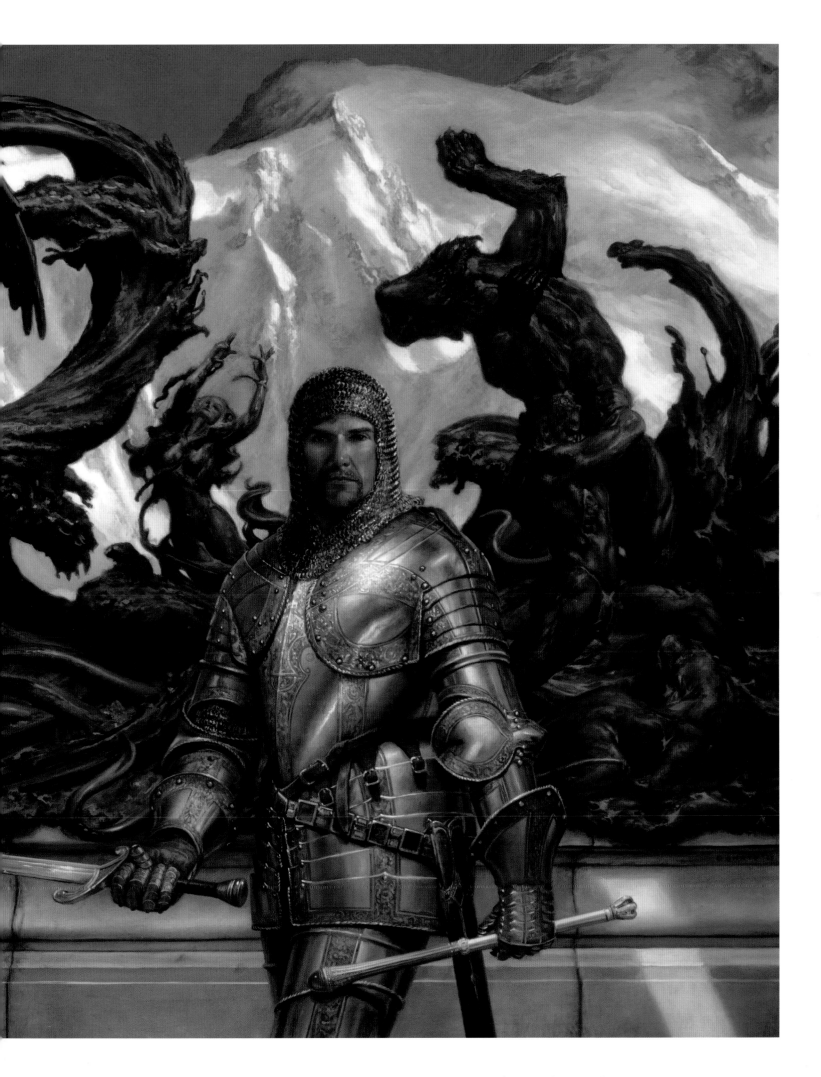

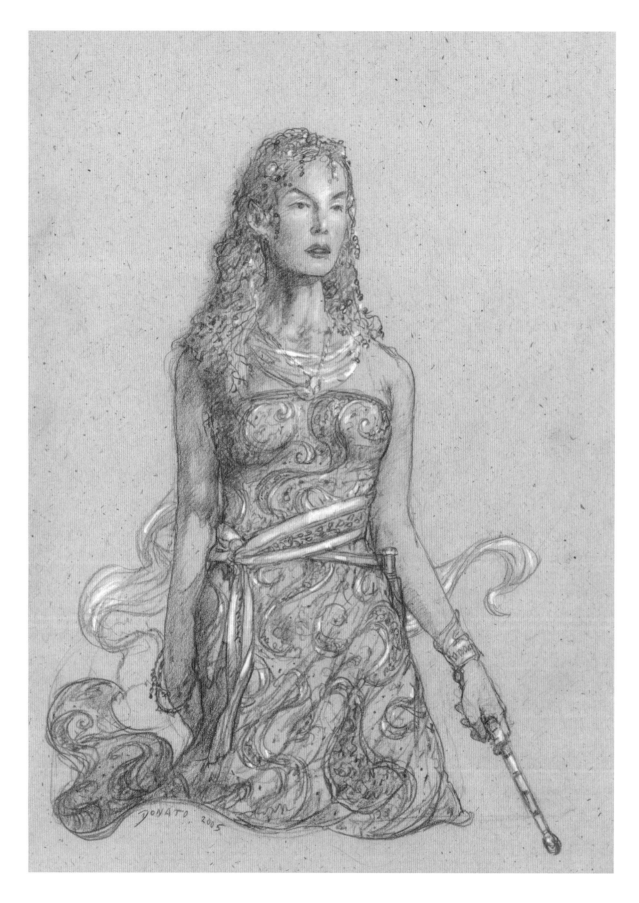

ABOVE: "Queen Arwen"
2005, 10" x 14", watercolor pencil and chalk on toned paper. Private collection.

OPPOSITE: "Aragorn in Rohan"
2003, 10" x 13", watercolor pencil and chalk on toned paper. Private collection.

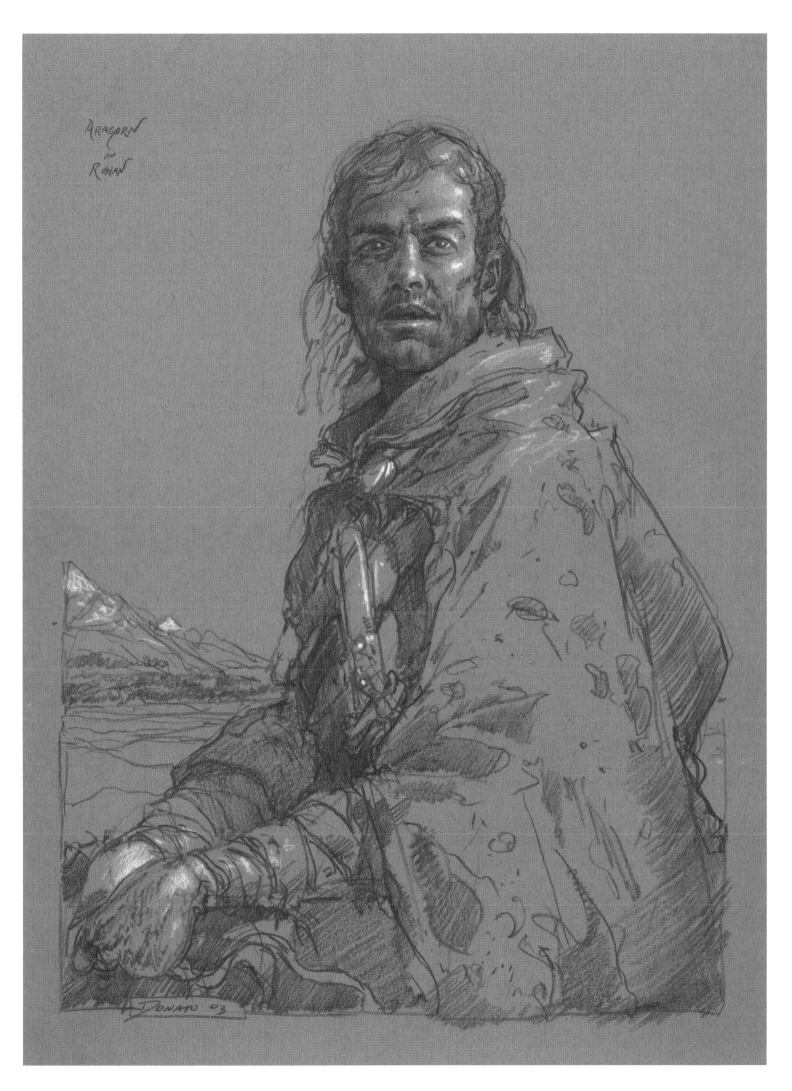

ARAGORN
in
ROHAN

Donato '03

ABOVE: "Elrond - The Map of Thorin"
1995, 8" x 10", oil on panel. Private collection.

OPPOSITE: "Elrond with Narsil"
2006, 9" x 12", watercolor pencil and chalk on toned paper. Private collection.

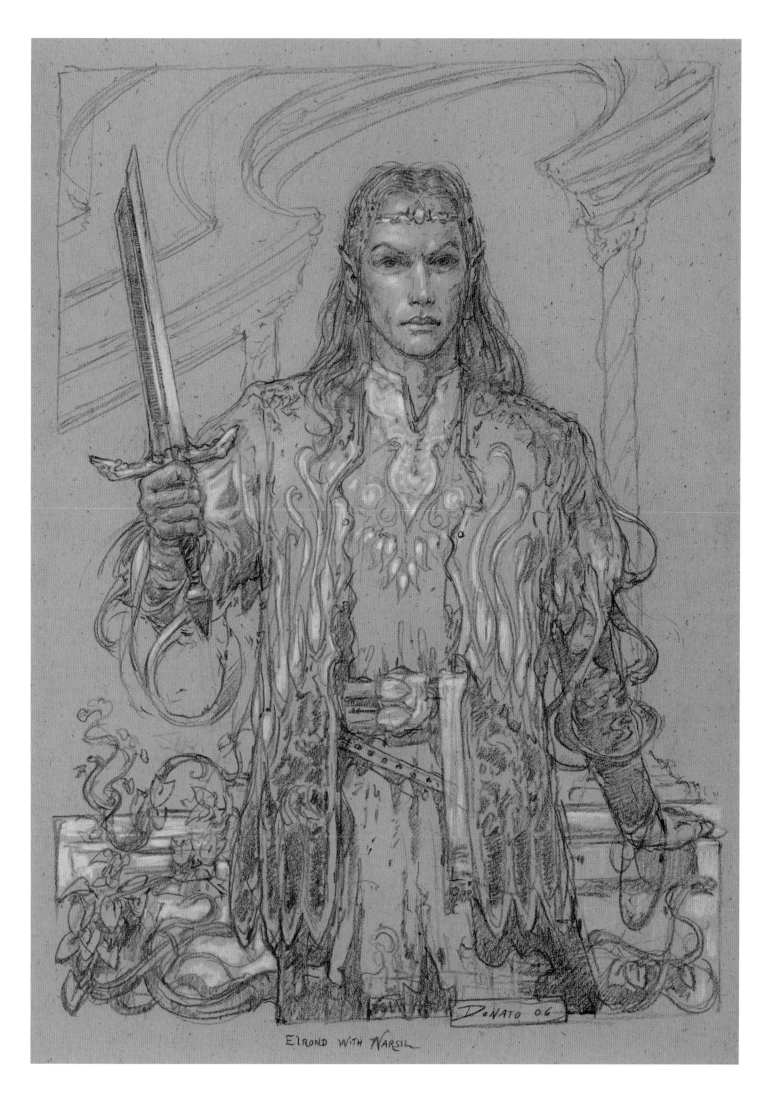

ELROND WITH NARSIL

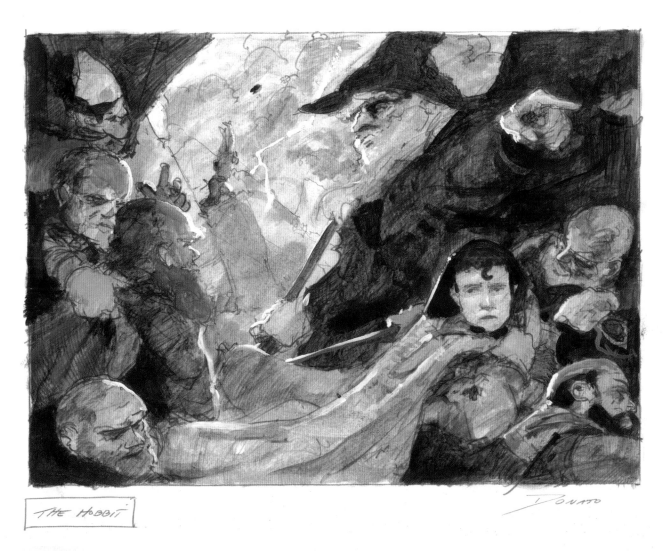

THE HOBBIT

DONATO

"THE DARKENING STREAM"

Donato 10-21-01

Creating a visual interpretation of an author's words is always a slippery slope, and, when that writer is J.R.R. Tolkien, the task is infinitely more difficult. Tolkien is an exquisite wordsmith, whose descriptive passages paint such wonderful images in the reader's mind that many feel they are transporting themselves out of our mundane world to the wonders of Middle Earth. When I first became a fan of Tolkien's books there were no published artworks available to the public other then the allegorical cover paintings. That all changed when the Hildebrandt brothers' amazing calendars hit the bookstores and sold out. Since then there have been a number of artists to interpret Tolkien's fantastic words into tangible visions, and I have been fortunate to be among an incredible collection of talented masters. There are many names to celebrate, such as, Alan Lee, John Howe, Ted Nasmith, Michael William Kaluta, Pauline Baynes, Michael Hague—and that brings me to Donato Giancola.

Donato first came to my attention when I met him at a comic convention in New York City as he was just entering the illustration field. He was a young man then, and he gave me a printed sample of his work. I was so impressed with it that I held onto it, knowing that Donato

would be making a very powerful artistic statement in the future. Little did I realize that his artistic vision would surpass my concept for what a painting could embody. Donato's talent is unsurpassed, and I don't say that lightly. As a fellow artist I find his mastery of painting and the figure to be sublime. His range of subject matter and the evocative images he renders are truly inspiring, which brings me to his Tolkien works.

Tolkien's words are very precise and that is why when we humble artists attempt to put flesh on them they often bear a resemblance to other artistic interpretations. Gandalf will always have a tall pointed blue hat and be wearing gray robes and tall black boots, as per *The Hobbit*. So the dilemma, for an artist interpreting Tolkien, is to translate the images faithfully to the text and then add something of themselves to make their images unique and different. Donato's Tolkien work embodies this artistic construct perfectly. I give as an example, *The Hobbit* graphic novel cover that he painted for the edition that came out to coincide with the first *Lord of the Rings* movie. When I saw the cover's collection of dwarves, I thought, "Here's an artist who has really added to the Tolkien text." Each dwarf was painted brilliantly, of course, but what struck me were the details. The tattooing, hair braiding and the jewelry he painted on each dwarf gave them a unique and distinctive presence that went beyond the written words. Each of Donato's Tolkien works embodies aspects of this same attention to translation and detail. It is not an easy task, as there are now so many Tolkien related images it is difficult for an artist to come up with something unique and fresh, but Donato transcends the task. Artists like Donato raise the bar for the rest of us. His skill, work ethic and ability to interpret the written word are inspirational. If you are not familiar with Donato's Tolkien paintings, hold on, because you are in for a visual ride that celebrates the melding of epic story telling with painting virtuosity.

—*David Wenzel*
January 2010

OPPOSITE & ABOVE: "The Hobbit: preliminary drawings" 2000, pencils and ink wash on paper.

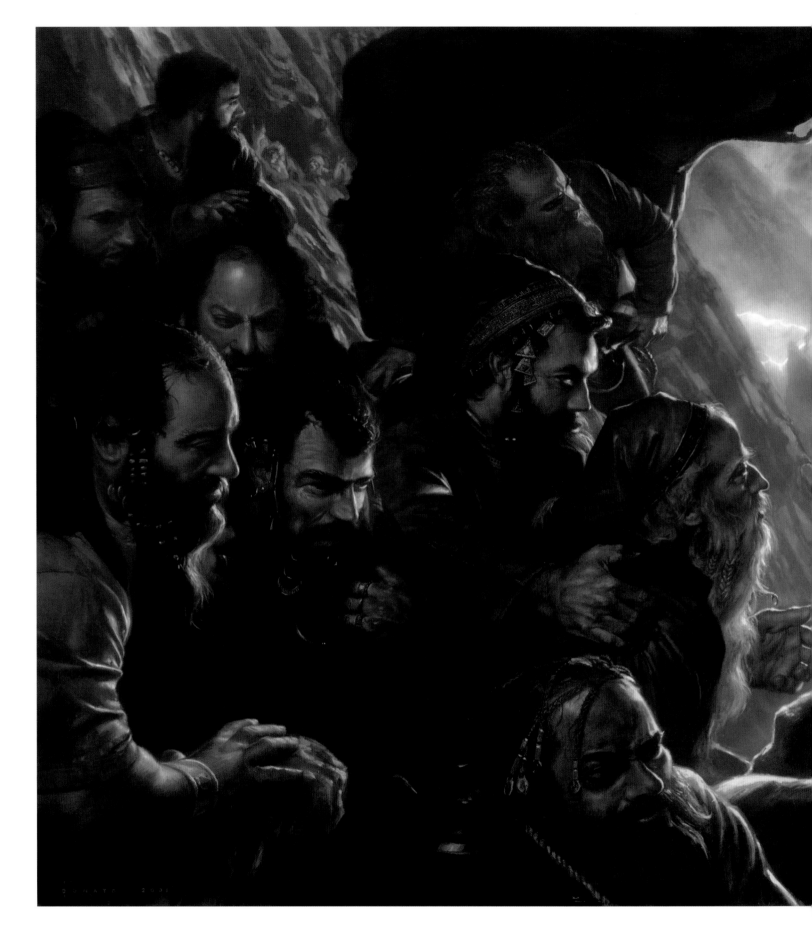

THE HOBBIT: EXPULSION

In this painting, Bilbo's semi-willing journey from his paradisical Shire, driven by curiosity, finds a parallel in the expulsion of Adam and Eve. Like the biblical first people, Bilbo finds himself thrown into a world of awe and terror; every encounter in *The Hobbit* makes this world ever larger and more complex for the provincial young man. Bilbo's humble and naive nature keeps him alive through his adventures, yet he is changed forever by his experiences in the outside world. Unlike Adam and Eve, Bilbo physically returns to his Eden, but he never again feels genuinely home in it.

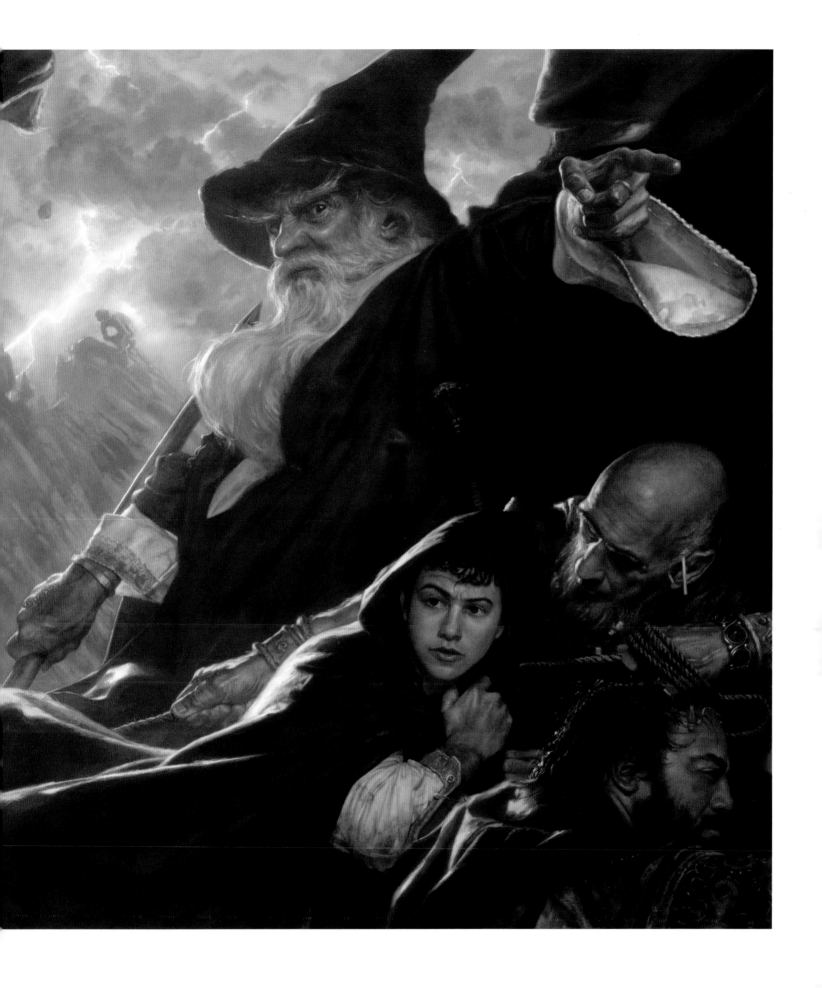

ABOVE: "The Hobbit: Expulsion"
2001, 68" x 38", oil on panel. Collection of the artist.

Donato Giancola **49**

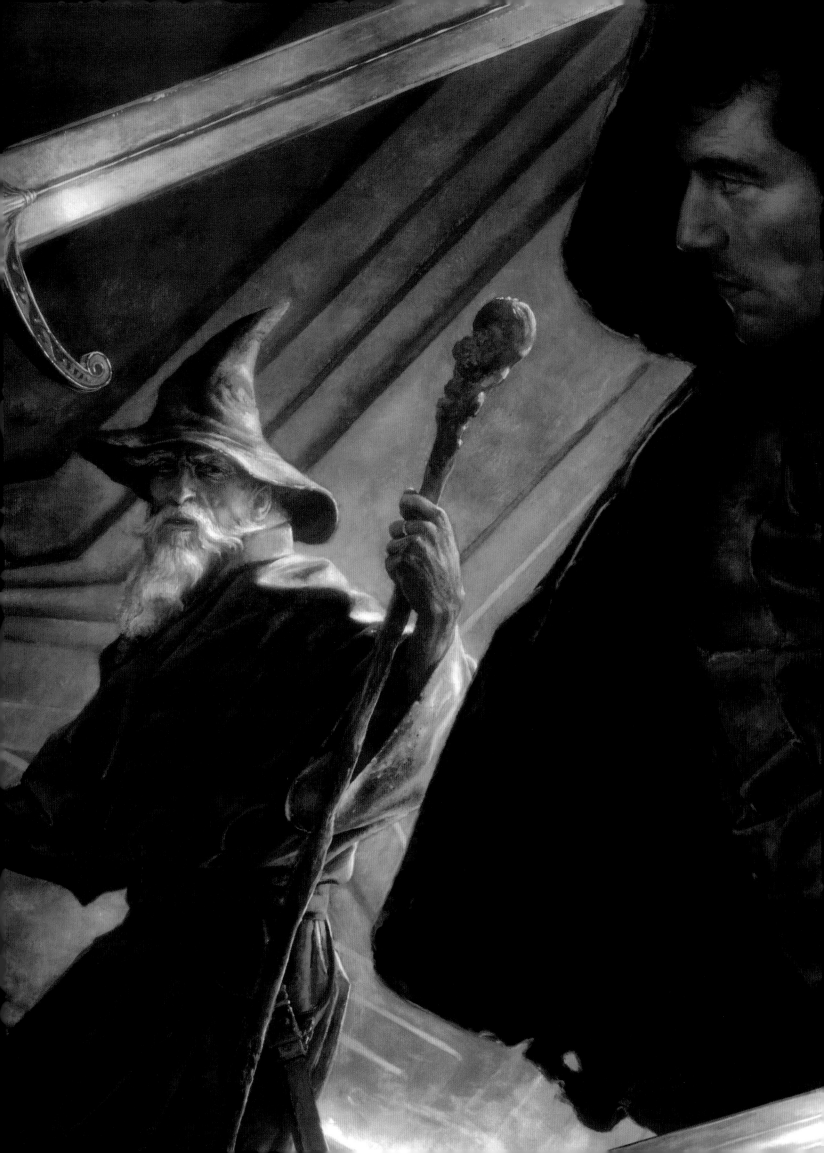

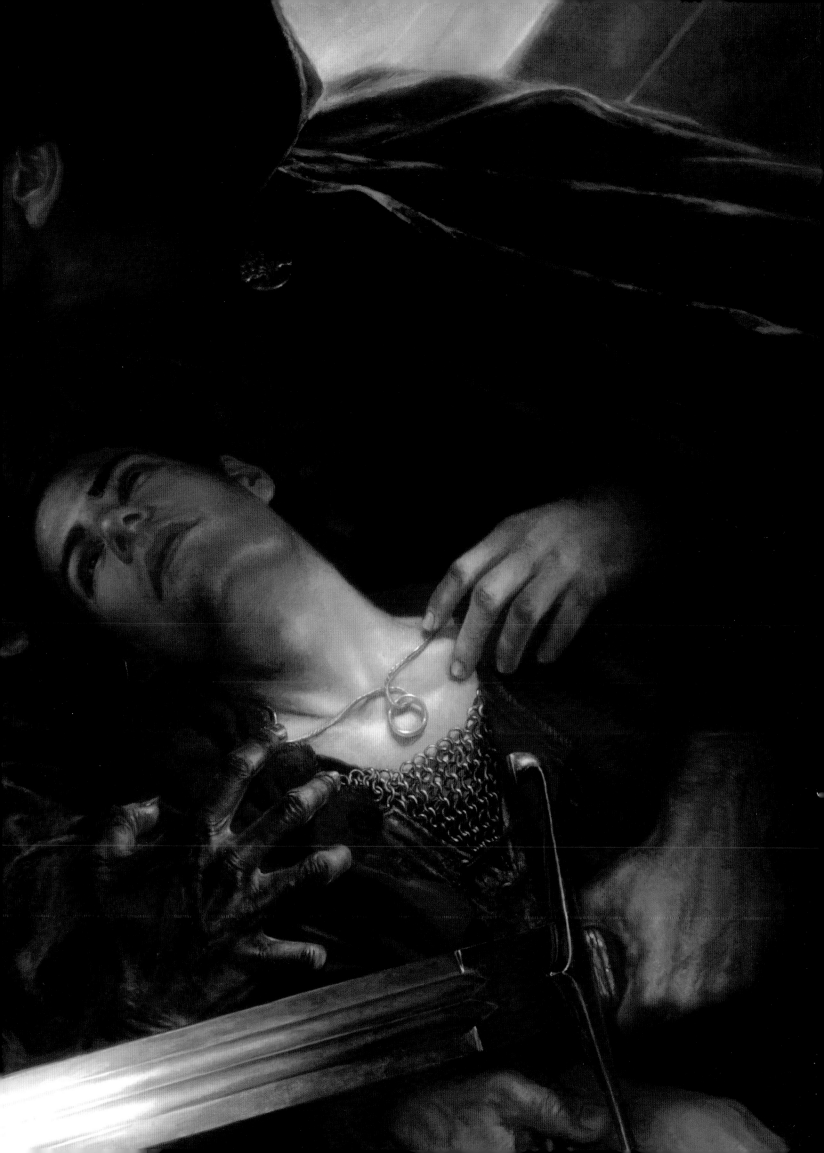

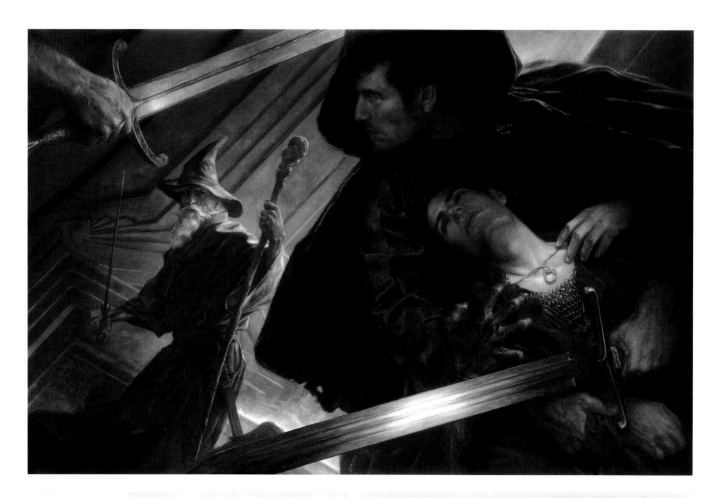

THE LORD OF THE RINGS

This cover for the Science Fiction Book Club's combined edition of *The Lord of the Rings* required a single narrative image that would convey the entire trilogy. Moria was one of the few places where the three main protagonists, Frodo, Gandalf and Aragorn, gathered. The physical battle in Balin's Tomb in Moria, however, is secondary to the psychological conflict over the ring. Frodo struggles as much within himself as he does with external forces. Here he is despicted as weary and defeated figure, his hand reaching out to the highlighted ring while another dark, groping hand echoes his gesture. That shadowy ambiguous hand might represent Sauron, Gollum or even what Frodo himself could become.

PREVIOUS SPREAD, TOP & OPPOSITE: "The Lord of the Rings"
1999, 55" x 33" oil on panel. Collection of Chris Huntley.

ABOVE:
"The Lord of the Rings—preliminary drawings", 1999, watercolor, pencils, and ink wash on paper.

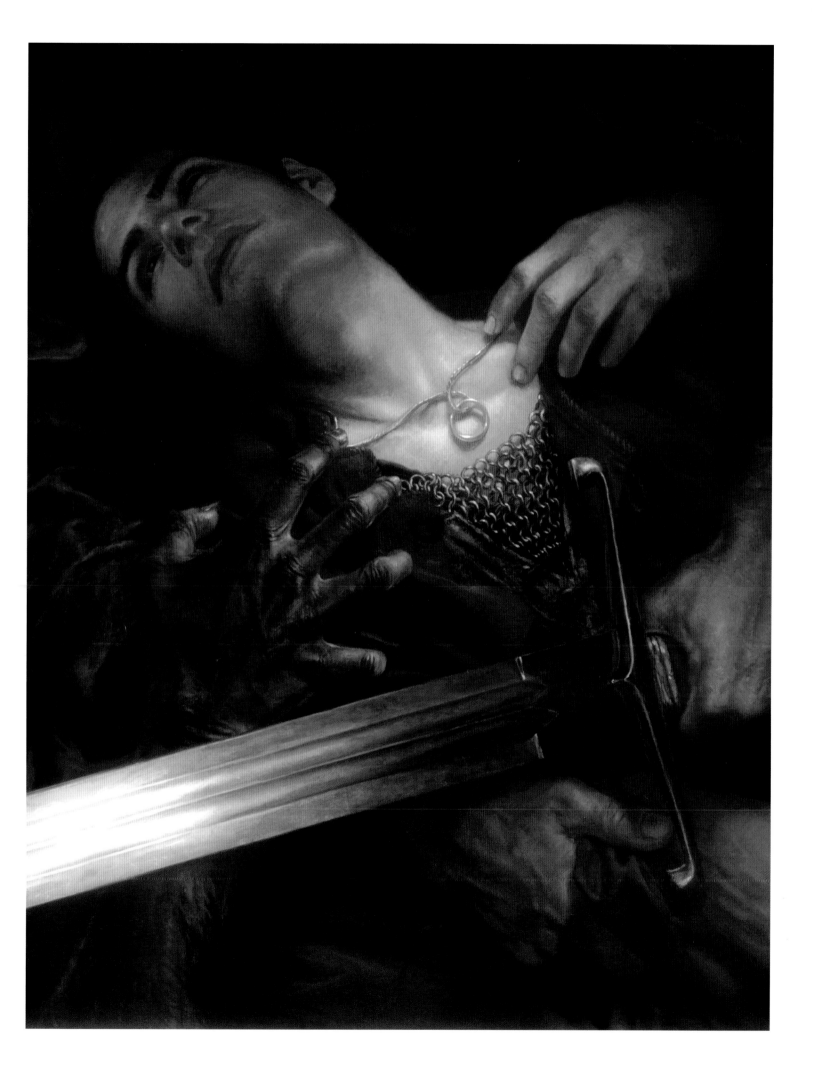

Then There Were Three

The richness of Middle-earth's history makes it easy to envision adventures beyond those found in the published works. Hobbits are generally peaceful and simple folk, but occasionally their curiosity gets the best of a few of them. Gandalf had a particular fondness for Bilbo's maternal ancestors, the curious and intrepid Tooks. This painting depicts an early hobbit adventure in the old forest, one that might have inspired Gandalf's admiring affection and eventually lead him to Bilbo's door years later.

ABOVE: "Green-Hill Country"
2010, 9" x 12", watercolor pencil and chalk on toned paper.

OPPOSITE: "Then There Were Three..."
2002, 33" x 48", oil on panel. Collection of Mateo Pascual.

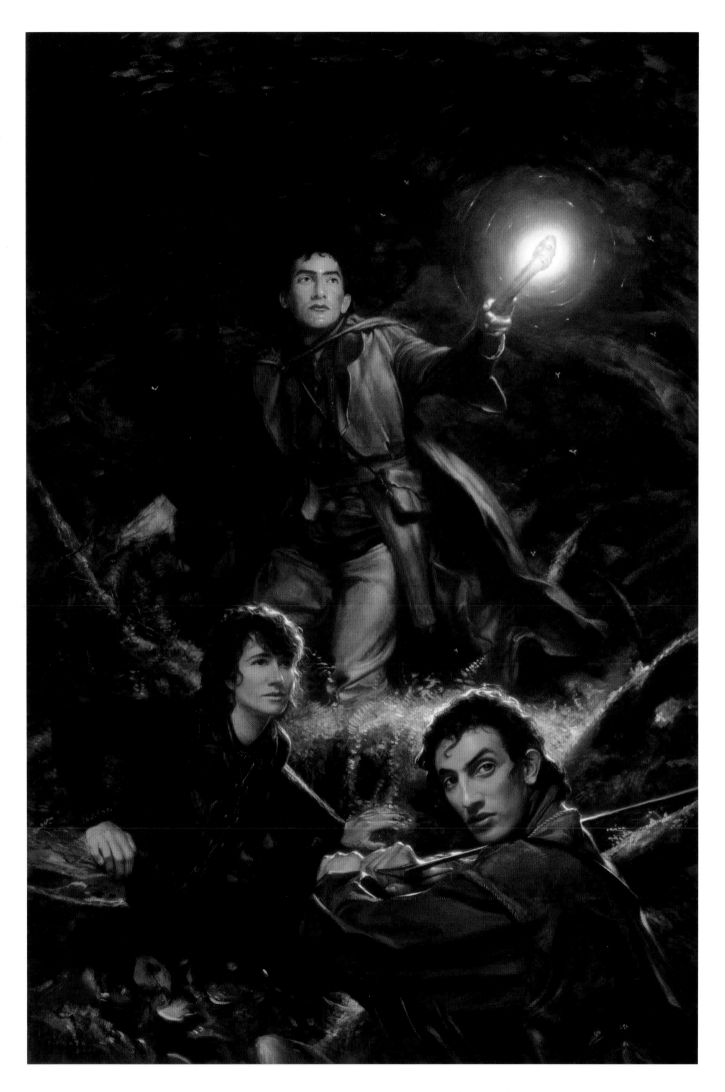

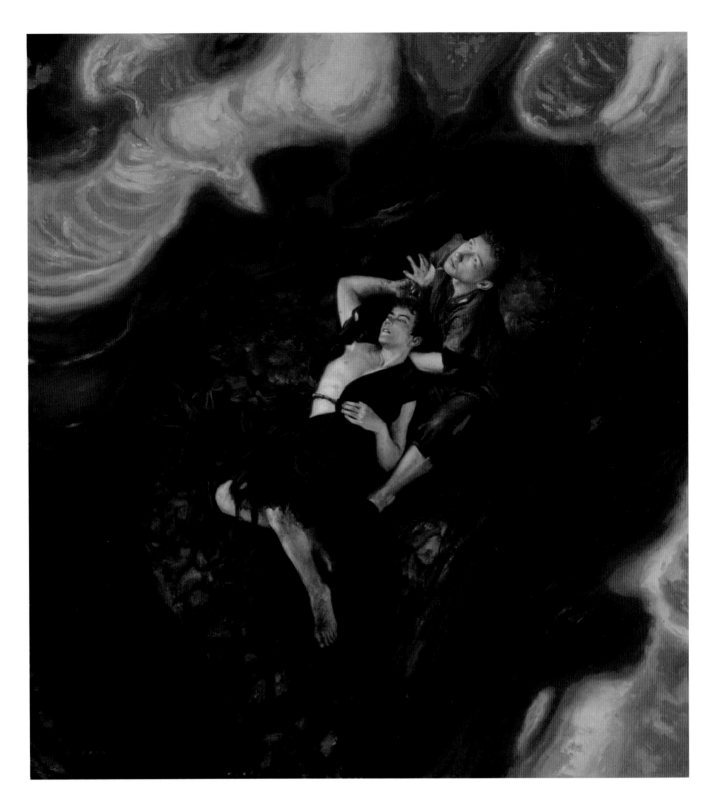

ON THE STEPS OF MOUNT DOOM

In the battle against the greatest evil of their time, the bond between two small hobbits becomes the most important tool against darkness—a beautifully profound concept. Frodo and Sam's friendship provides the requisite strength for their arduous and sometimes reluctant journey, on which hangs the fate of Middle-earth. Their enduring bond becomes a treasured reward after the quest is achieved.

ABOVE: "On the Steps of Mount Doom"
2002, 27" x 30", oil on panel. Private collection.

OPPOSITE: "The Tower of Cirith Ungol"
2010, 14" x 17", watercolor pencil and chalk on toned paper.

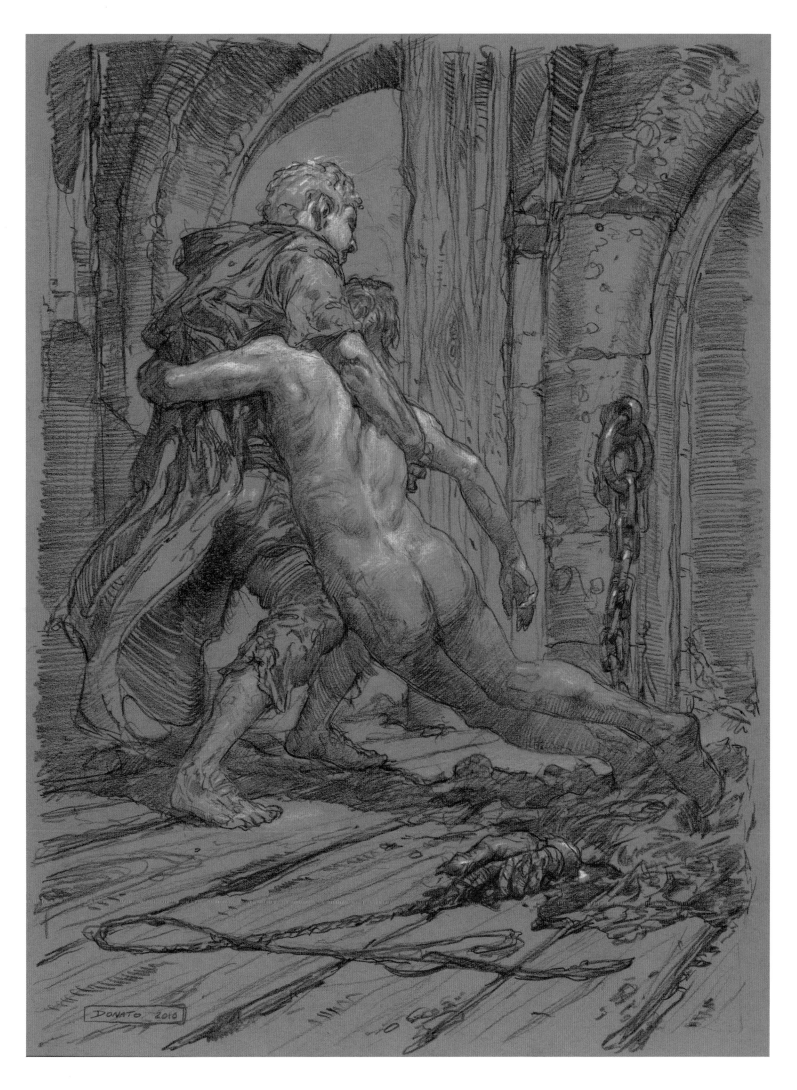

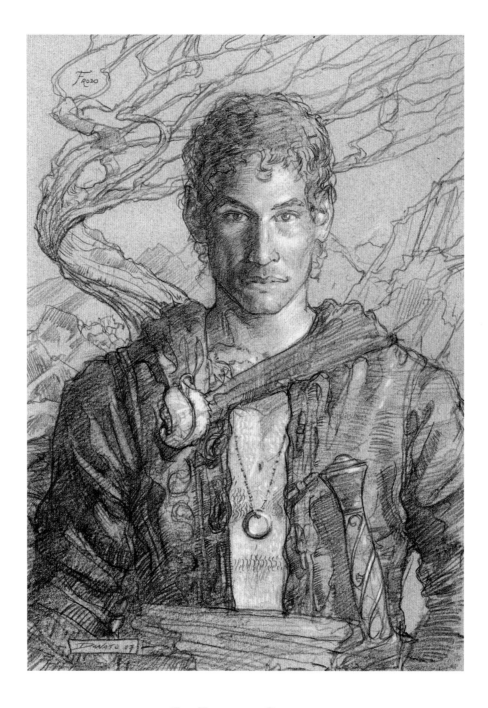

The Taming of Smeagol

Frodo and Gollum's relationship, the most psychological and symbolic in *The Lord of the Rings*, reveals a dark labyrinth of choices and split personalities. On the surface Gollum shows what Frodo could become should he succumb to the ring's powerful temptations, but by sparing Gollum and mastering his own temptations, Frodo chooses his own salvation, both body and soul. This painting echoes Judas' cruel and tender kiss, identifying the savior, since ultimately and unexpectedly, Frodo's conflicted mercy leads to the unwilling sacrifice of Smeagol, which heals all Middle-earth.

Above: "Frodo"
2007, 10" x 14", watercolor pencil and chalk on toned paper. Private collection.

Opposite: "The Taming of Smeagol"
2010, 36" x 48", oil on panel.

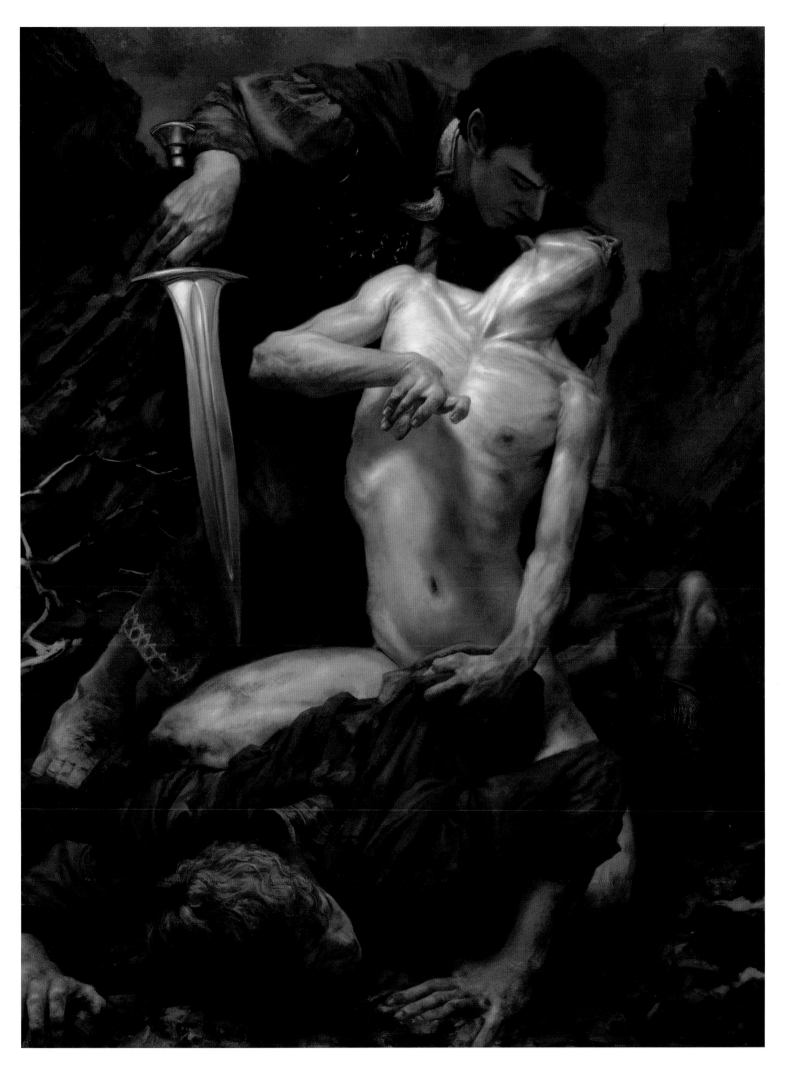

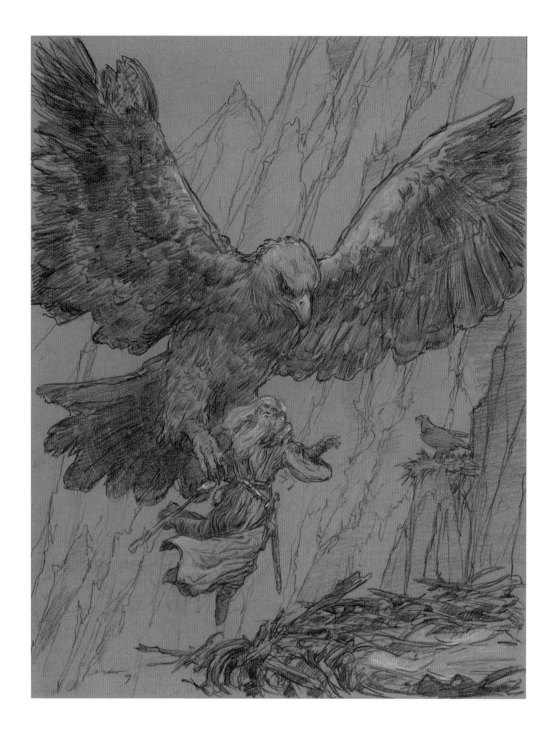

Out of the Frying Pan, Into the Fire

Eagles appear in Tolkien's major works as unlooked-for solutions to difficult predicaments and as noble foils to the enemy's horrific flying creatures. They show up when all hope seems lost, as if emissaries from the gods, the Valar.

Above: "Gandalf and the Lord of Eagles"
2009, 14" x 17", watercolor pencil and chalk on toned paper.

Opposite: "Out of the Frying Pan, Into the Fire"
2009, 24" x 30", oil on panel.

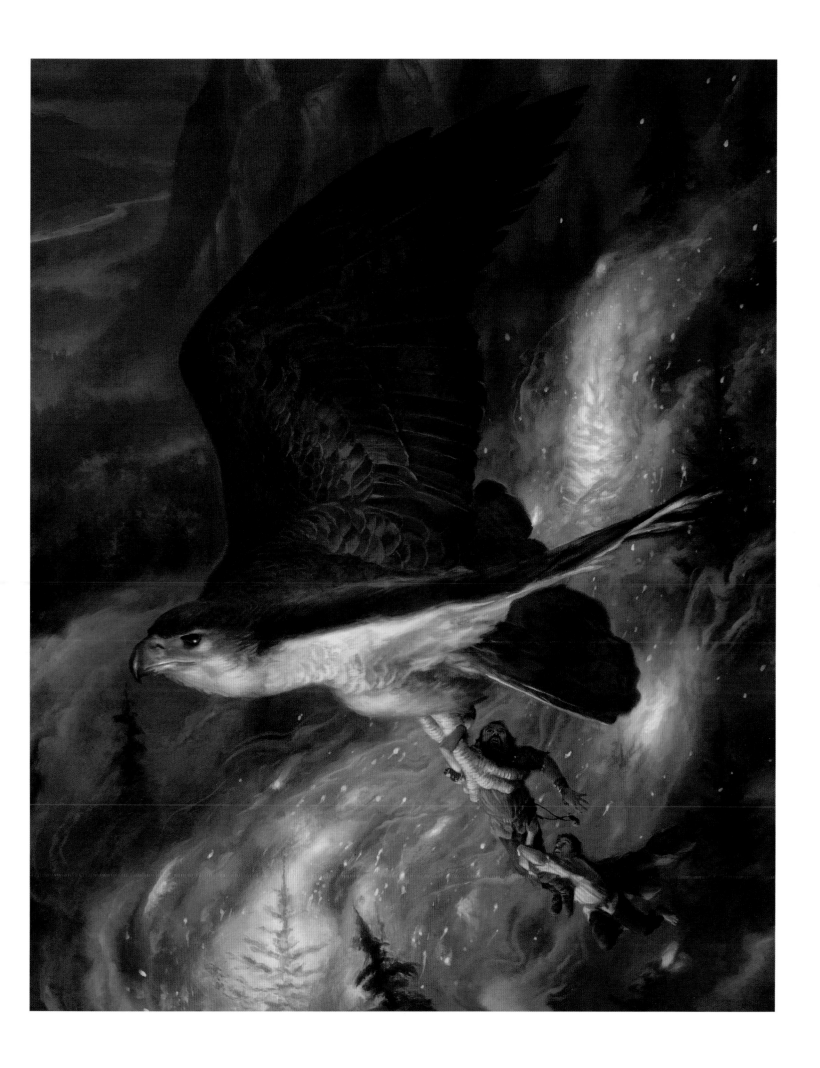

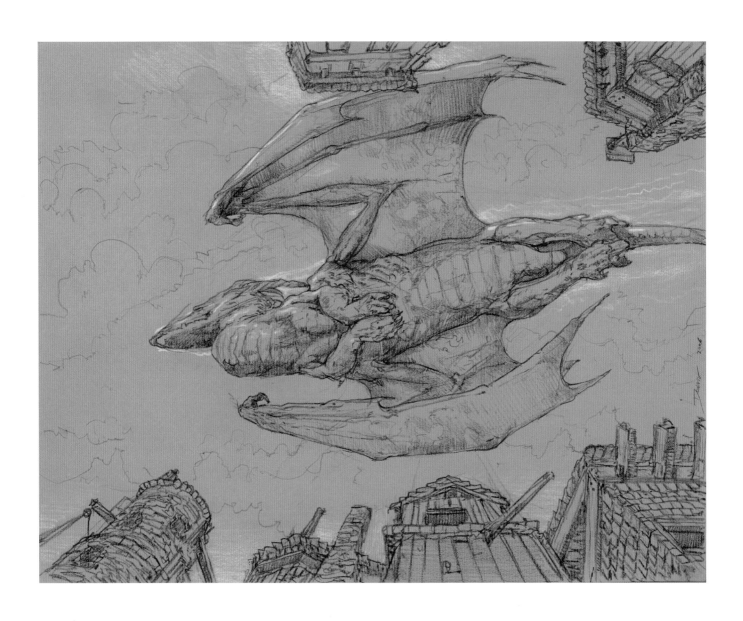

The Great Dragon Smaug

Smaug has become the quintessential dragon of fantasy literature, a fiercely defensive, ancient, wily hoarder. While it is unclear whether Smaug is the last dragon in Middle-earth, his presence and subsequent death during *The Hobbit* is an indicator of the passing of an age. While Smaug may have been the fiercest monster a small hobbit could imagine, the conflicts between the smaller creatures of men, orcs, dwarves, and elves mark the real confrontations in *The Hobbit*. Tolkien himself served in World War I and may have drawn from his personal experiences when writing about the mighty and fearsome battle of Five Armies.

ABOVE: "Smaug over Laketown"
2007, 13" x 10", watercolor, pencil, and chalk on toned paper. Private collection.

OPPOSITE: "The Great Dragon Smaug"
2000, 30" x 37", oil on panel. Collection of Chris Huntley.

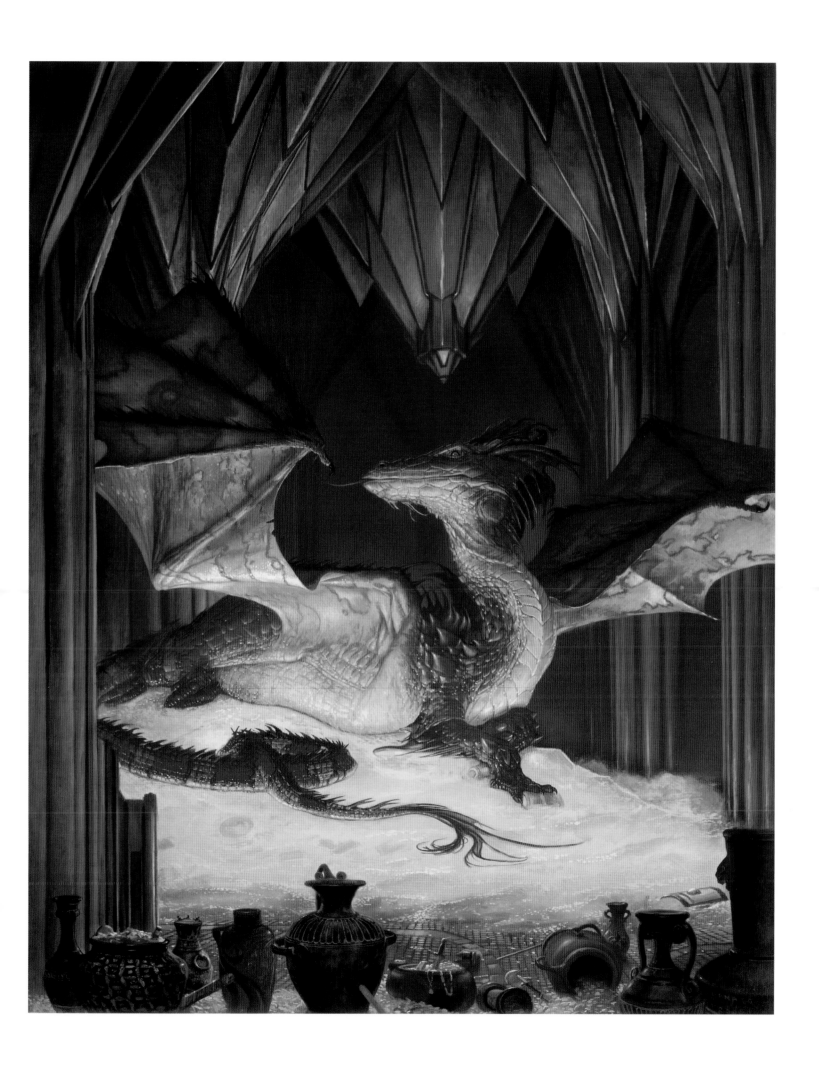

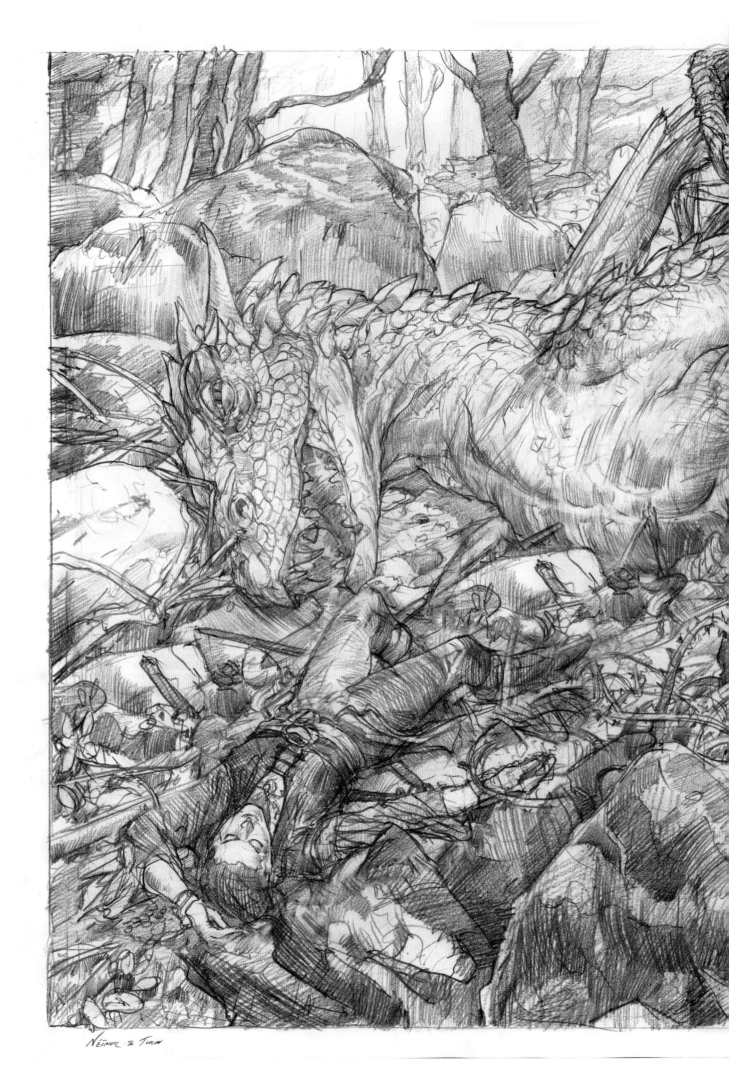

Níenor & Túrin

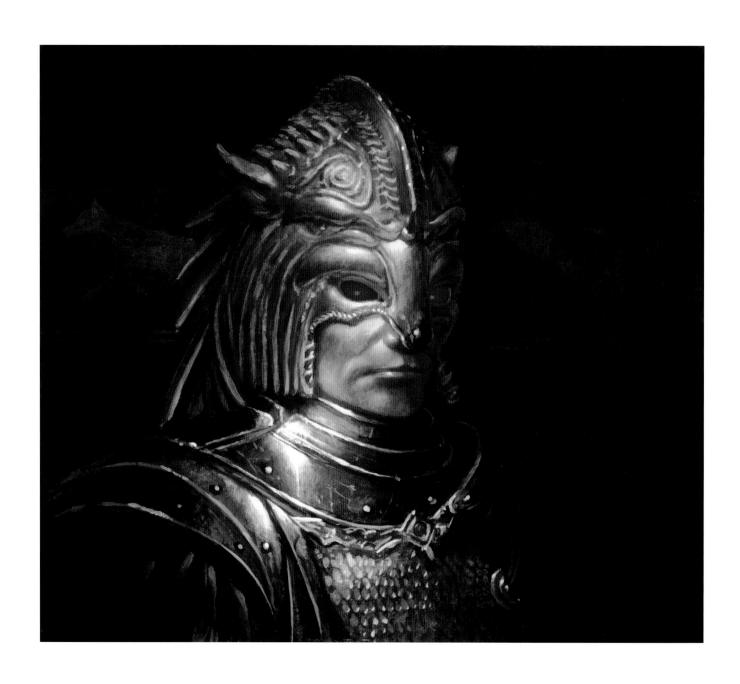

PREVIOUS SPREAD: "Nienor and Turin"
2007, 40" x 30", pencil on paper.

ABOVE: "Dwar of Waw: One of the Nine Ringwraiths"
1997, 9" x 8", oil on panel. Collection of Liz Danforth.

OPPOSITE: "The Witch King of Angmar"
2005, 10" x 14", watercolor pencil and chalk on toned paper. Private collection.

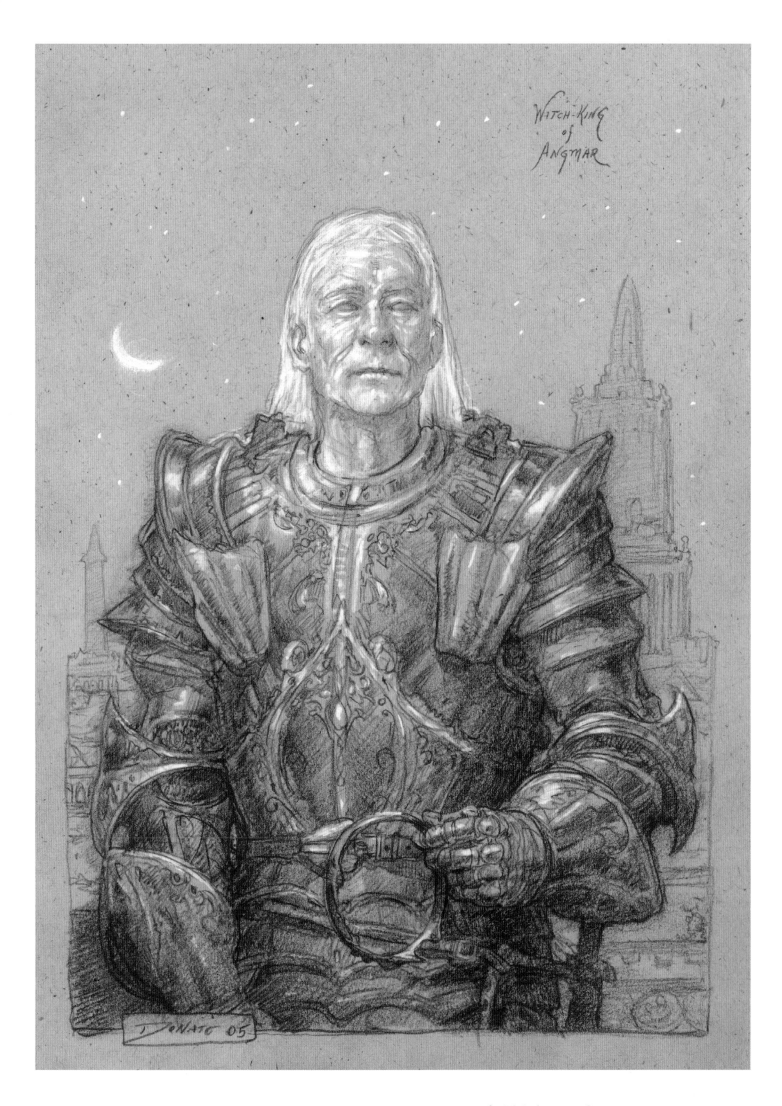

WITCH-KING
of
ANGMAR

Donato Giancola **67**

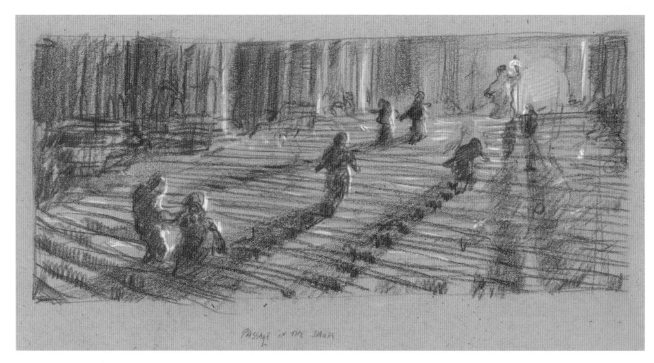

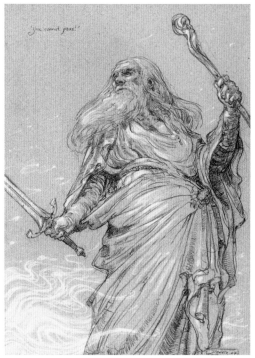

GANDALF IN MORIA

 Moria is Gandalf's Gethsemane, where the hero struggles with and eventually accepts his fate. Being the leader of the Fellowship, Gandalf is continuously faced with difficult, perilous choices. Here I chose to depict a moment of quiet contemplation in Moria, a hint of pipe smoke suggesting time passed in troubled thought before Gandalf the Grey's final battle.

TOP & ABOVE LEFT: "Passage in the Dark: rough drawings"
2003, 9" x 12", watercolor pencil and chalk on toned paper.

ABOVE RIGHT: "You Cannot Pass!"
2007, 10" x 14", watercolor pencil and chalk on toned paper. Private collection.

OPPOSITE: "Gandalf in Moria"
2002, 14" x 20", oil on panel. Private collection.

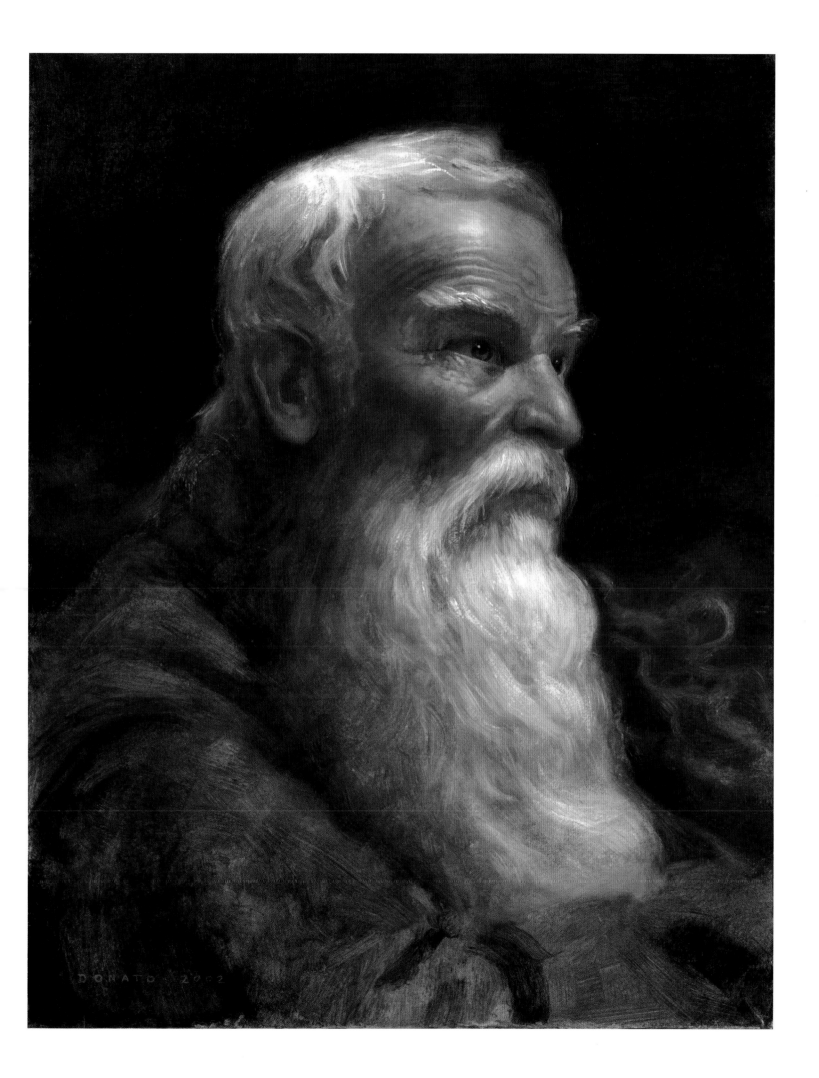

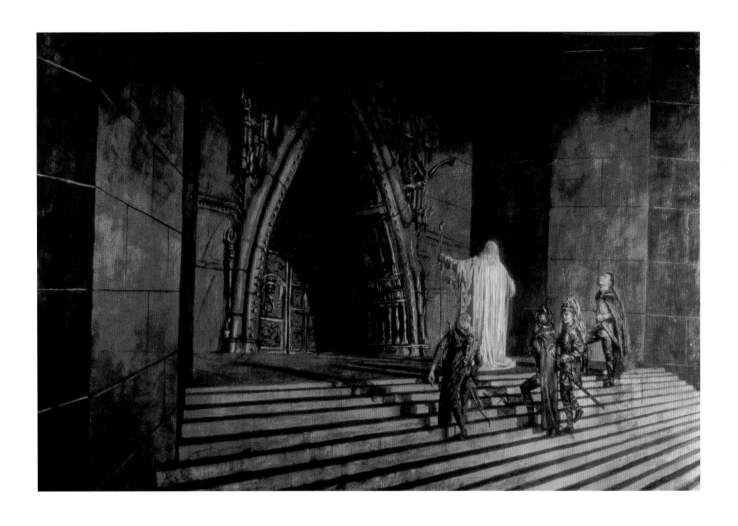

The Voice of Saruman

In *The Two Towers* and later in *Return of the King*, Saruman's voice is never without great effect, even after his staff is broken. His voice becomes something more than the wizard himself, almost its own character. Removing Saruman from the scene, his voice is left to fill the space in front of Orthanc.

ABOVE: "The Steps of Isengard"
1991, 24" x 36", acrylic on panel.

OPPOSITE: "The Voice of Saruman"
2009, 13" x 17", watercolor pencil and chalk on toned paper.

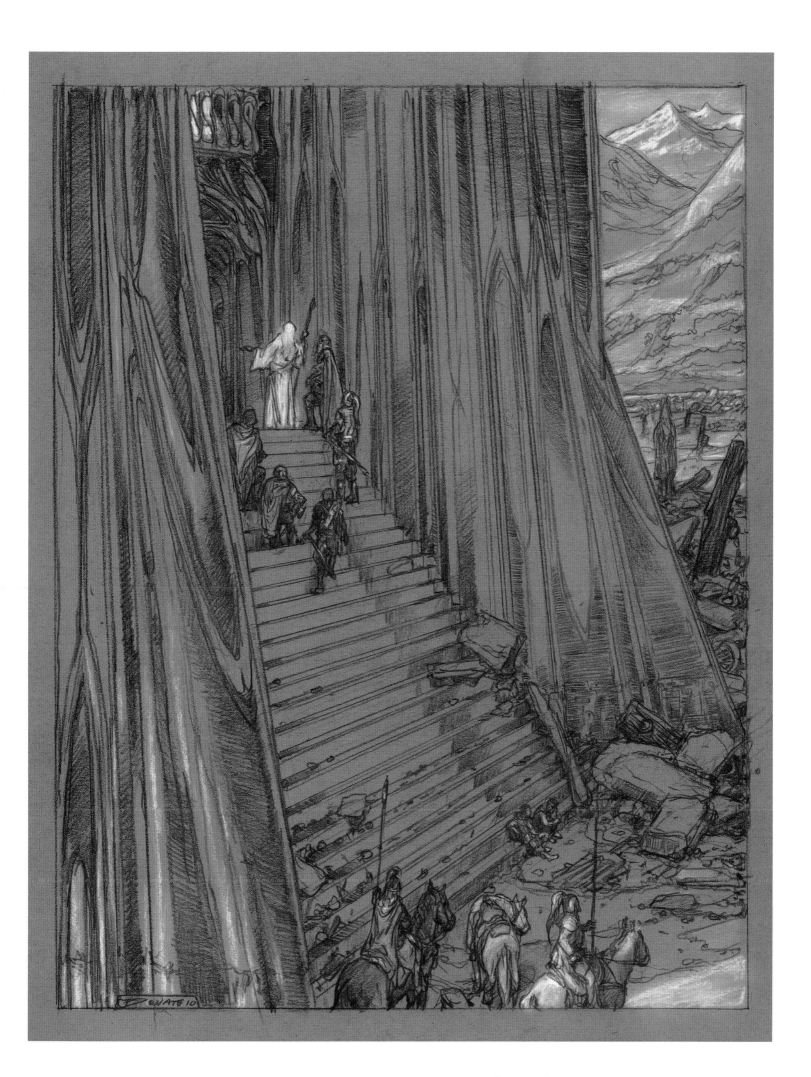

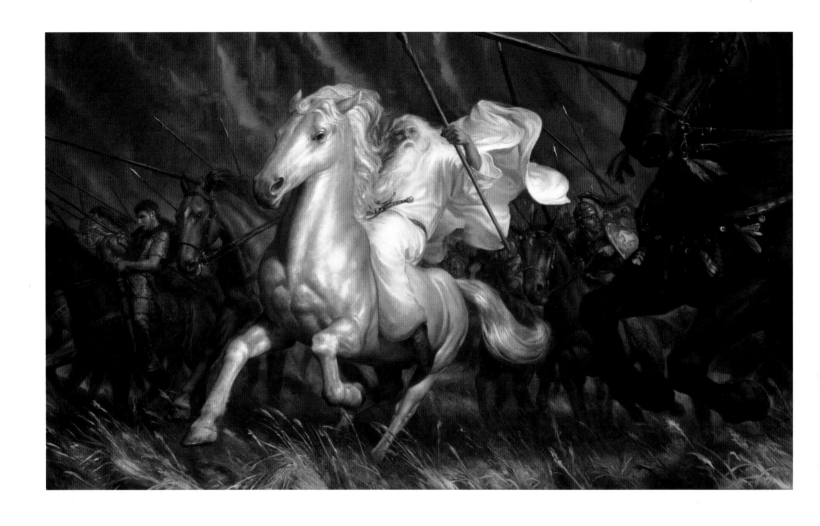

GANDALF: THE WHITE RIDER

After his confrontation with the Balrog, Gandalf is sent back to Middle-earth in a new form and empowered to lead men against the forces of Sauron. Gandalf the White publicly reveals himself when he delivers King Theoden of Rohan from Saruman's spell. The glowing and determined Gandalf serves as a beacon for men, riding amongst them and inspiring hope and courage. As a unifying figure, Gandalf the White stands in luminous opposition to the dark, divisive Sauron.

ABOVE & OPPOSITE: "Gandalf: The White Rider"
2004-9, 60" x 38", oil on panel.

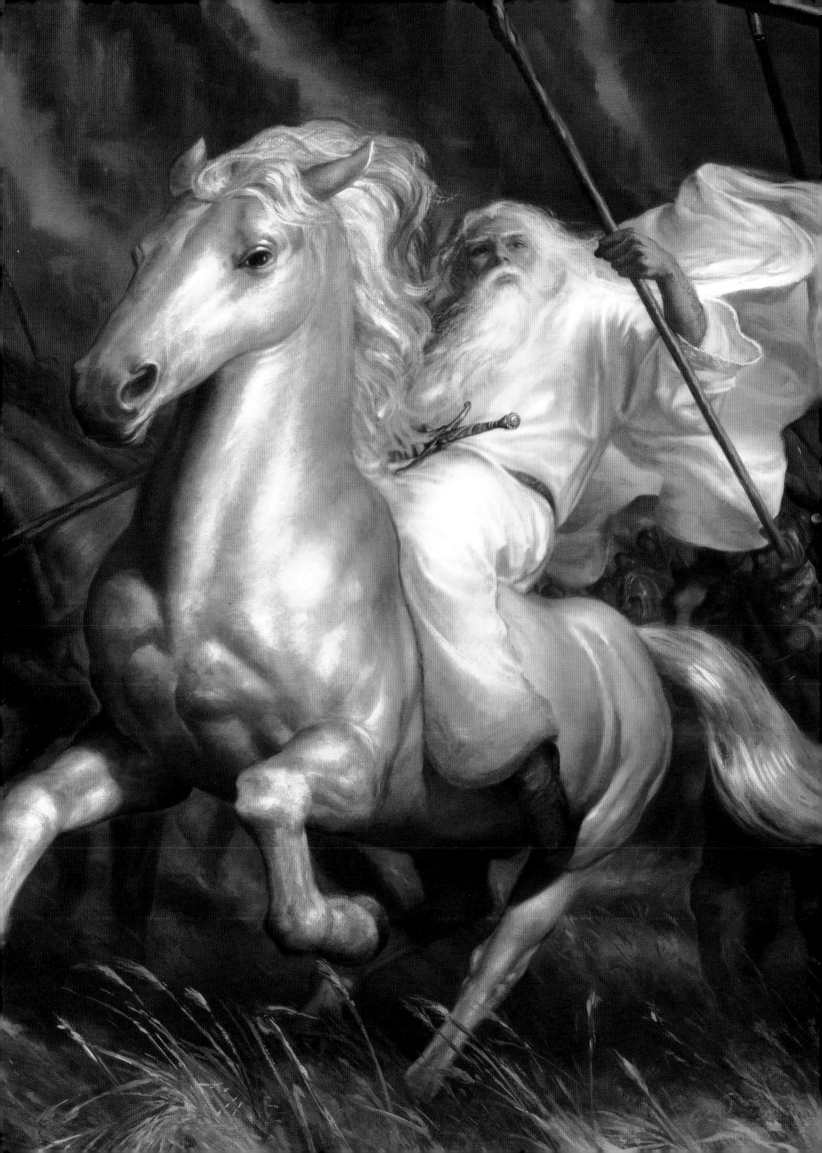

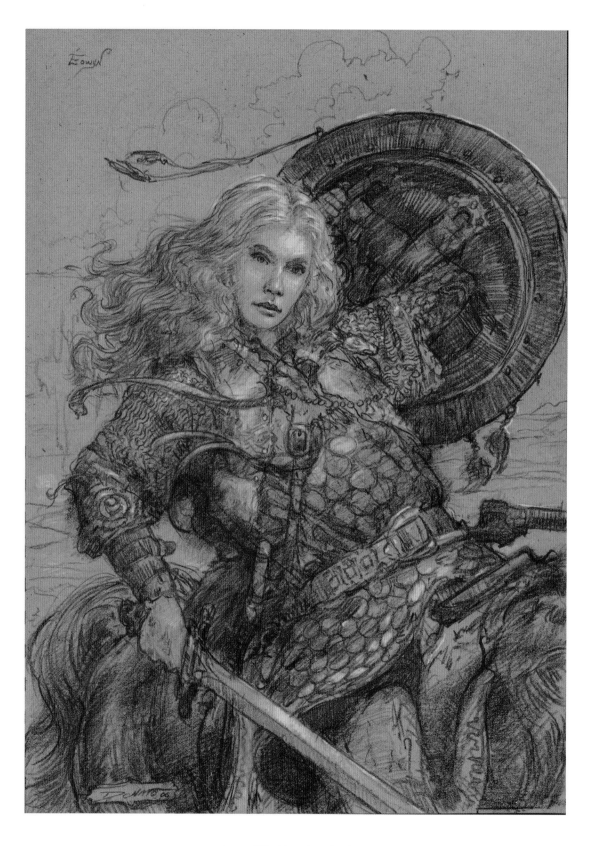

Above: "Shieldmaiden of Rohan"
2006, 13" x 17", watercolor pencil and chalk on toned paper.

Opposite: "Éowyn of Rohan"
2002, 13" x 17", watercolor pencil and chalk on toned paper.

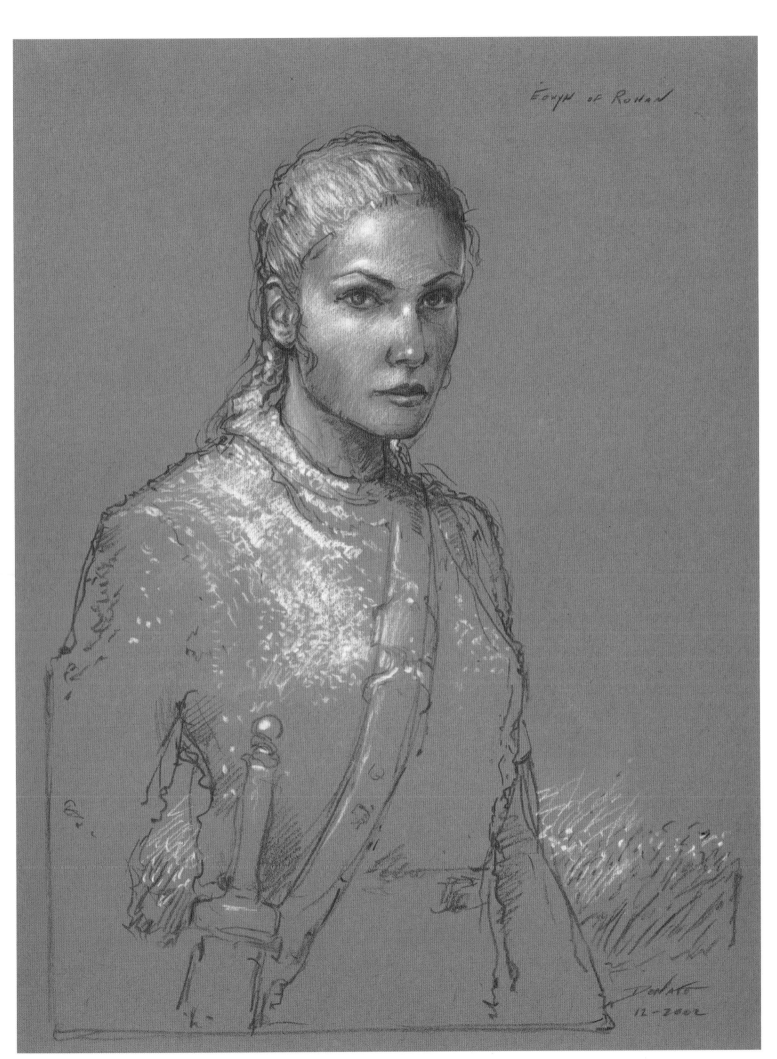

Éowyn of Rohan

Donato
12-2002

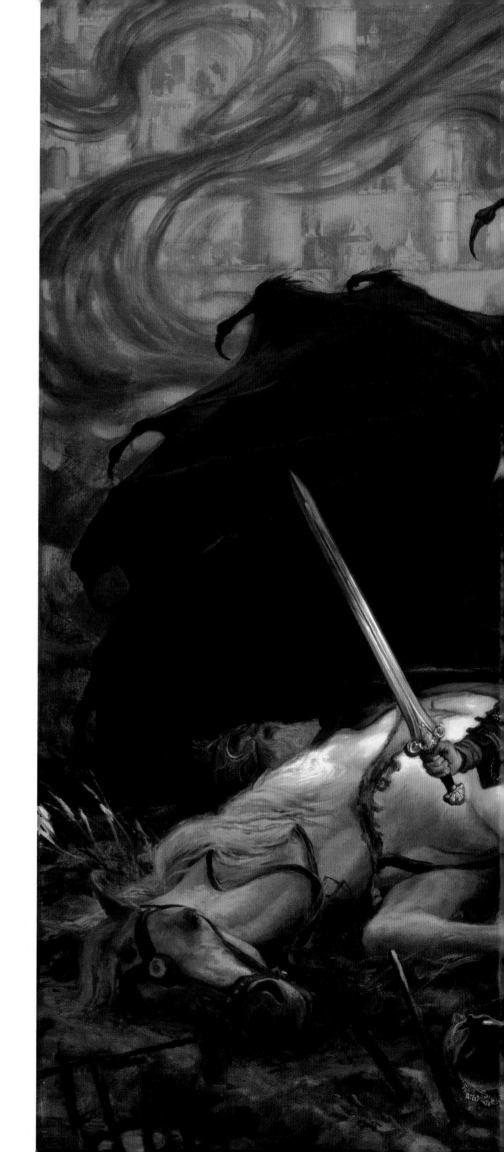

ÉOWYN AND THE LORD OF THE NAZGUL

Tolkien's storytelling satisfies in part because he makes personal victories as important as grand battles. Character accomplishments directly translate into larger triumphs. When Éowyn slays the Witch-king during the siege of Minas Tirith, we cheer as she conquers not only the enemy but also her own fears of inadequacy, giving the story scale and heart.

OPPOSITE: "Éowyn and the Lord of the Nazgul" 2010, 40" x 36", oil on panel. Private collection.

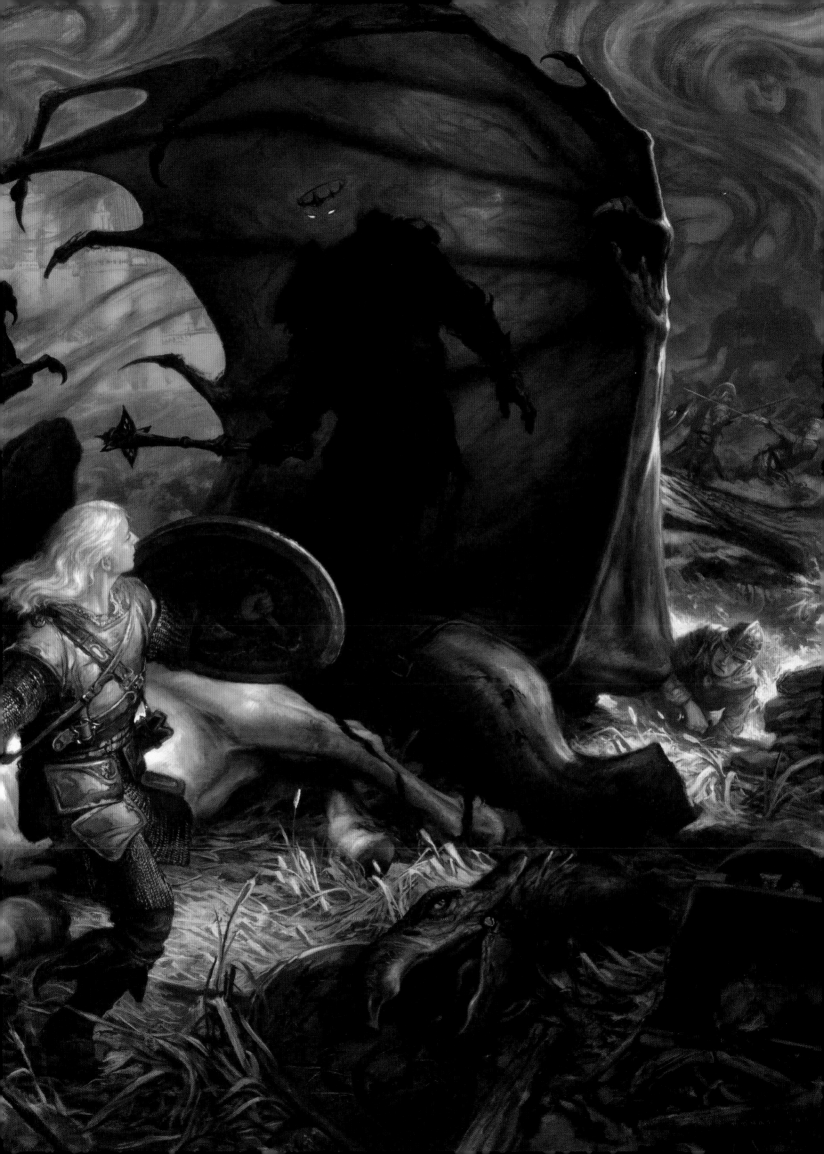

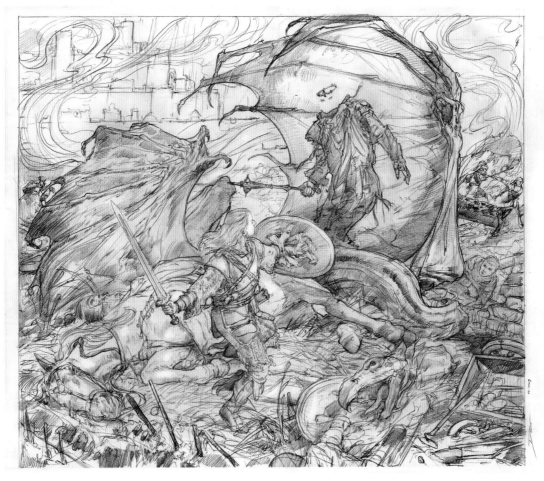

Above: "Éowyn and Nazgul rough drawings"
2009, watercolor pencil and chalk on toned paper.

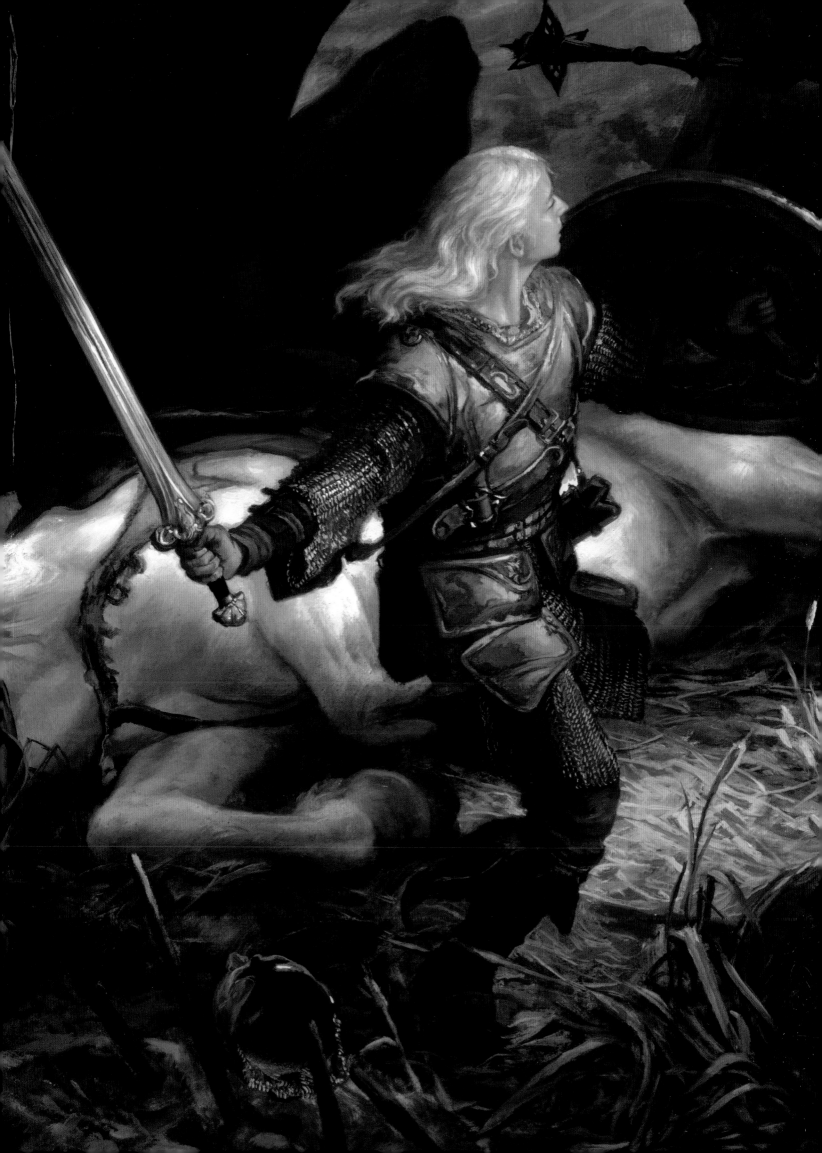

ABOVE: "Telchar of Nogrod forging Narsil"
2010, 5"x7", oil on paper. Private collection.

From J.R.R. Tolkiens' *The Lord of the Rings* to Botticelli's "La Primivera," Donato Giancola balances modern concepts with realism in his paintings to bridge the worlds of contemporary and historical figurative arts. His influences encompass visits to local game shops and book stores as well as pilgrimages to the greatest of museums - including the Uffizi, Louvre, and Hermitage. Donato recognizes the significant cultural role played by visual art and makes personal efforts to contribute to the expansion and appreciation of the science fiction and fantasy genre that extend beyond the commercial commissions of his clients. To those ends, the artist teaches at the School of Visual Arts in New York City and appears at various institutions, tournaments, and conventions, from San Diego to Rome to Moscow, where he performs demonstrations in oil paint and lectures on his aesthetics.

Born in 1967 and raised in Colchester, Vermont, USA, art was a perpetual obsession. As a young man, he would steal away into the basement of his parents' home to work on drawings, create his own maps for the game *Dungeons & Dragons,* paint figurines, read comics, and construct model tanks and dinosaurs. Donato enrolled in his first formal art class at the age of twenty, beginning his professional training.

Immediately after graduating *Summa Cum Laude* with a BFA in Painting from Syracuse University in 1992, Donato moved to New York City to immerse himself in its inspired and varied art scene. When not spending long days of study in NYC's museums, Donato apprenticed as a studio assistant to the preeminent figure painter, Vincent Desiderio. It was then that his love and appreciation of classical figurative art took hold. He continues his training even now, visiting museums regularly, learning from and sometimes copying original paintings by Rembrandt or Rubens, attending life drawing sessions with illustrator friends and constantly challenging himself with each new project. Pilgrimages to major museums are his preferred reason to travel.

Since beginning his professional career in 1993, Donato's list of clients extends from major book publishers in New York to concept design firms on the West Coast: notables include The United Nations, LucasArts, *National Geographic*, CNN, DC Comics, Microsoft, *The Village Voice, Playboy Magazine,* Wizards of the Coast, Scholastic, Simon&Schuster, Tor Books, Random House, Time/Warner, The Scifi Channel, Milton-Bradley, and Hasbro. Merits range from the Hamilton King Award from the Society of Illustrators in 2008 to eighteen Chesley Awards from the Association of Science Fiction and Fantasy Artists, three Artist Hugo Awards for outstanding professional work from the World Science Fiction Society, notable awards from the Art Renewal Center, and multiple silver and gold medals from the juried annual *Spectrum: The Best of Contemporary Fantastic Art.*

He lives with his wife and two daughters in Brooklyn, New York.

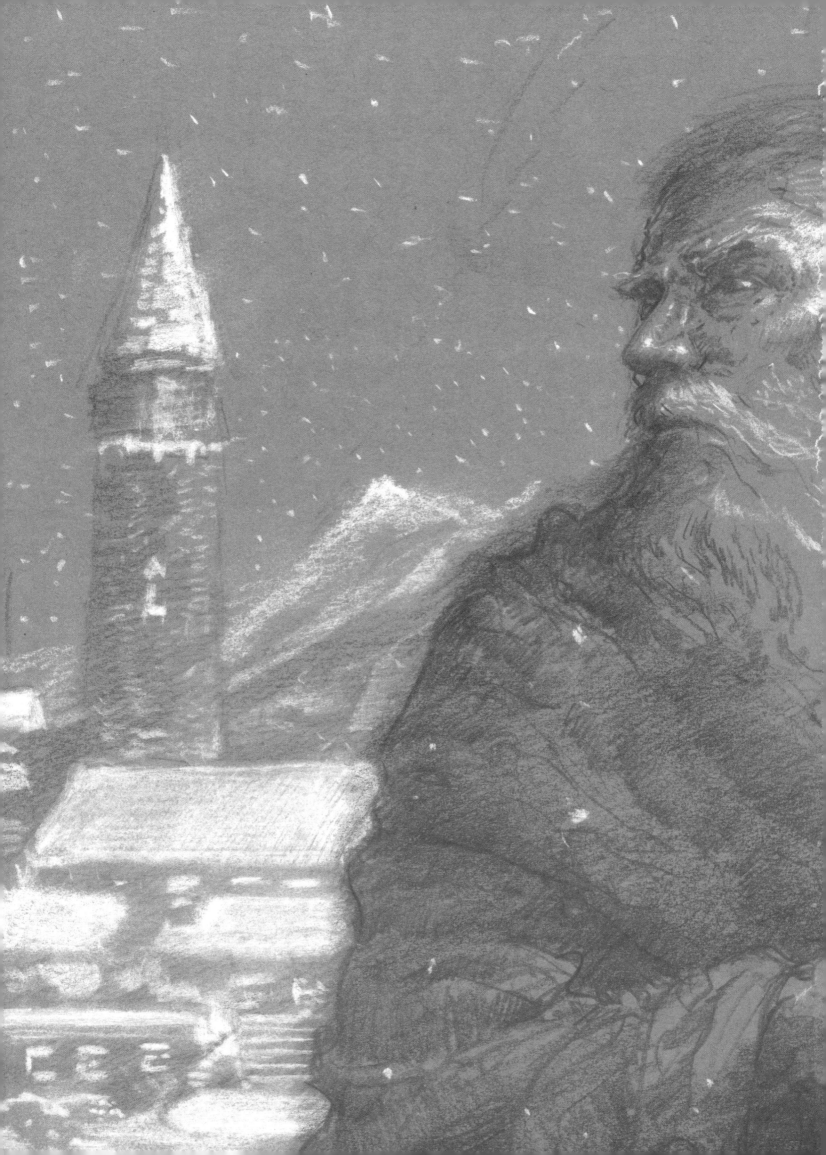